NEWFOUNDLAND · LABRADOR

Photographs by SHERMAN HINES

Introduction and captions by RAY GUY

NIMBUS PUBLISHING LIMITED

ISBN 0-920852-28-9

Photographs taken with: Pentax 6×7 using
Ektachrome and Contax camera 35mm
using Kodachrome.

Design by Graphic Design Associates.
Printed and bound in Hong Kong by
Everbest Printing Company Limited.
Published by Nimbus Publishing Limited,
P.O. Box 9301, Station A, Halifax,
Nova Scotia, B3K 5N5

Canadian Cataloguing in Publication Data
Hines, Sherman, 1941 -
 Newfoundland and Labrador
ISBN 0-920852-28-9
1. Newfoundland - Description and travel - 1950 - Views.*
2. Labrador - Description and travel - Views. I. Guy, Ray.
II. Title.
FC2162.H56 1984 917.18'0022'2 C84-098414-6
F1122.8.H56 1984

Introduction

Size, climate and variety: these are the pleasant surprises most often mentioned by first-time visitors to Newfoundland and Labrador. In this splendid sampler by Sherman Hines, these have been admirably captured.

You could very well breakfast in St. John's and have lunch in Labrador City, but only after a flight of more than 1,000 miles. The province is as big as New Brunswick, Nova Scotia, England, Wales and Ireland put together – with 10,000 square miles to spare. In northern Labrador the Torngat mountains rise to nearly 6,000 feet while on the west coast of the island there are peaks to 2,600 feet, some of which drop sheer to the sea.

The Churchill River, with a falls eighty feet higher than Niagara, is one of the great waterways of Canada. Lakes and rivers on the island are smaller but they're everywhere. Travellers have compared them to those of Finland.

There are about 560,000 of us, of whom one-fifth live in and around the capital, St. John's.

It's been said that Americans sometimes bring skis to Toronto in July. Tourists have come here toting surfboards and snowshoes, snake-bite kits and Arctic survival gear. There are no snakes at all but the other three bits of baggage may come in handy depending on the time and place. While a sweater might be enough on choice days in February you may wish you'd brought your parka on a few ill-favored days in June.

Island climate is marine and Labrador's is continental but we sometimes call it a lot worse than that. However, *"she's never so black as she's sometimes painted."* Goose Bay's four seasons are like Edmonton's and, in some years, you can pick a slightly bedraggled vase of flowers for the Christmas dinner table if you're on the South Coast or the Avalon Peninsula.

St. John's is closer to Moscow than it is to Vancouver. It's also on the same line of latitude that passes more than 100 miles south of Paris and touches northern Italy. But a province that's 1,100 miles tall obviously has a wide range of climate and the insular part can have four seasons in one day.

There's often fog along the coasts but if after a few days (or a few weeks!) it starts to pall, you have only to move five or 10 miles inland and there's the sun and the temperature leaps 20 degrees.

Variety is found not only in the weather. Although St. John's is now a modern city, its old core has a unique flavor many visitors find hard to describe. An international town planner once told me it reminded him of Dublin set down on the Isle of Skye; some see a bit of San Francisco; an artist says he's found the same "quality of light" in only two other places – Naples and Dallas.

East and west coasts of the island are completely different. The west has been likened to parts of Norway or Scotland and even described as a smaller-scale version of the British Columbia coast. The east, settled for more than 400 years, is lower, rocky and largely treeless with a fishing village in most of the hundreds of coves. Labrador is a land of farther horizons, vast forests, rivers, lakes and mountains... one of the last frontiers.

Newfoundlanders, although ninety-five percent are of English and Irish descent, speak in a variety of accents with words and phrases from old Ireland and from Shakespeare's day. We have a long reputation for politeness and hospitality but are sometimes embarassed by personal compliments from strangers. What really pleases and serves the same purpose is an admiring word about Newfoundland and Labrador itself for nowhere are people and place more closely united as one.

Ray Guy

Captions

1. Giant flotillas of icebergs pass down the east and west coasts of Newfoundland each spring, many grounding near the coast to be slowly destroyed by the increasing heat of early summer.

2. A lighthouse marks the entrance to Francois on the south coast of the island.

3. Remnants of a gale kicks up spray on a cobblestone beach.

4. Bay de Verde, Conception Bay, a prosperous fishing town which looks out on Baccalieu Island.

5. Sunday is still a day of rest as these boats at a calm mooring show.

6. Three jolly fishermen show off one of the more bizarre denizens of the deeps, a sculpin.

7. Rock formation near Turk's Cove, Conception Bay.

8. A subtle blend of stone and seaweed near a village whose name recalls a time when pirates were known as *turks* – Turk's Cove, Conception Bay.

9. A distinctive landmark at Nain, Labrador, is the steeple of the Moravian church whose congregation maintains a brass band, well known at music and folk festivals in the province.

10. Mountains, forests, rivers – all are on a grander scale in Labrador with peaks in the northern Torngats rising to 5,300 feet, virgin coniferous forests covering much of its southern half and the Churchill River.

11. On trapping grounds north of Nain an igloo takes shape from blocks of snow crust. Coastal Labrador is shared by diverse peoples: natives, both Innu and Innuit; *livyers*, permanent residents of white and mixed ancestry who live here; floaters, summer fishermen from the island who generally live aboard ship; missionaries; government workers; the military personnel of three or four countries.

12. The craft of weilding an ice knife to build a habitation from nothing but snow has not been entirely lost in Labrador.

13. Bush planes are of great importance in Labrador where roads are few and coastal ice bars shipping for more than half the year.

14. At Ramea with its ice-free harbor, fishing may continue all year and this longliner is brought ashore for its annual inspection at the spring tides.

15. Longliners moored beneath the towering cliffs of a south coast village.

16. Orange *blubber barrels* in a fishing shed, used to hold cod livers, not whale fat, for rendering of their oil.

17. Small boats at anchor behind a breakwater at sunset.

18. Men of all ages sit and watch the bustle on the harbor when the coastal ferry boat calls at a south coast community.

19. TWISTY ANN, possibly named because of her bad habits in a stiff breeze, rests from her labors at a dock near Grand Bank on the Burin Peninsula.

20. North Atlantic spider crab is no less delicious now that it's been rechristened snow crab for the sake of the mainland market.

21. Two-thirds up the coast of Labrador is Nain, the province's most northerly community, founded in the late 1700s by Moravian missionaries and claimed by some to lie at the

boundary of Helluland (Land of Flat Stones) to the north and Markland (Land of Forests), so named by the Vikings prior to 100 A.D.

22. As elsewhere in the north, the dog team in Labrador and northern Newfoundland has largely given way to the motorized toboggan. Yet some still prefer the old ways.

23. Mid-morning tea where the winters are long and the snow lies deep at Postville, Labrador.

24. On the coast of Labrador, new fishing boats are cut from the forest by the same man who builds and sails the finished craft.

25. The renowned polite friendliness of Newfoundlanders shows in the faces of two girls on the way to the shop, a fisherman-farmer cutting seed potatoes, some boys cooling their hot wheels on a small bridge and a happy miss pausing at play on a beach.

26. At Grand Beach on the Burin peninsula one-and-a-half dories are drawn up on the shingle, one to take on stone ballast for wharf repairs and the other a possible victim of the past winter's storms.

27. An old house along the Conception Bay Highway has been converted to a barn and shed and painted the appropriate color, like the nearby outhouse and root cellar.

28. Building has always been in wood and, except for dates on headstones as here in this Trinity Bay community, there may be little obvious evidence that some *outports* are centuries old.

29. Longliners and dories.

30. Most communities have a *government wharf* and here most of the fishing activity is centered.

31. More than 95 percent of Newfoundlanders are said to have either southwest England or southern Ireland in their ancestry. In the red hair and freckles of this young girl, Waterford would seem to have it over Devonshire.

32. Pastel colors are further muted by coastal fog here at Monkstown, Placentia Bay. A few miles inland the sun may be shining and the temperature ten degrees higher.

33. Under laundry flapping is a spring breeze a fisherman pauses during annual repairs to his boat.

34. Winterton, Trinity Bay.

35. A typical slice of community life can as easily be found within the city limits of St. John's or Corner Brook as in some remote outport unconnected by road.

36. Tubs of *lines* are readied for the fishing grounds where they are strung out for miles with thousands of baited hooks dangling from them.

37. Goose Cove on the Northern Peninsula where Vikings settled about 1,000 A.D.

38. At Grand Falls and at Corner Brook great stacks of pulpwood, constantly renewed, are landmarks of these paper towns.

39. Wild iris, squaw or cracker berry, beach pea and (top, left) the pitcher plant, floral emblem of Newfoundland, depicted on the coat of arms and, once, on stamps and coins.

40. Catails are common only in the reedy marshes of the island's west coast.

41. Summer freedom now for these horses which haul firewood, fence railings and boat timbers from the forests in winter and plow and till the subsistence vegetable gardens in spring.

42. Double saturation of color of house and fishing sheds reflected in a calm cove. Newfoundlanders are fearless in the use of vivid and contrasting paints.

43. Baker's Brook Falls in winter, Gros Morne National Park.

44. In villages not yet connected by road both the Canadian Coast Guard and C.N. coastal ferries still provide a vital service and a link with the world.

45. An oil drilling rig at night, one of the increasing number working the huge gas and oil reserves around Newfoundland and Labrador.

46. Two icebergs on their journey south pass a strip of molten sunset in the Strait of Belle Isle.

47. Caribou in winter at Gros Morne National Park.

48. It might be 25°C and high summer but some years massive hard-dying icebergs thrill tourists on parts of the northern coast.

49. A typical section of rocky coast although there are several beaches of startlingly white sand and, in Labrador, an almost unbroken 45-mile stretch of yellow sand and rolling dunes known as Porcupine Strand.

50, 51. *Yard art* flourishes especially around summer cabins but also in front of many homes such as here, at the residence of G.L. Snow, Victoria, Conception Bay, where discarded toys, found objects, moose antlers, plywood cutouts and even the cracks in the walkway are a painstaking riot of red, white and blue.

52. Gull Island.

53. Dark green is the color still favored for small fishing boats but this craft gets a brighter spring coat of yellow and tangerine.

54. Commonwealth, Canadian and Newfoundland flags are flown in front of provincial buildings, but many unofficial flags may be seen including a pink, white and green tricolor of times past, and a blue, green and white Labrador flag.

55. Both the inshore and offshore fisheries are represented here by the small white boat dwarfed by trawlers.

56. Nearly 500 years of European history in the New World is compressed in this view of St. John's from the harbor in the foreground, to the old business district of Water Street, to the churches and schools further up the slope, to Confederation Building, seat of provincial government at left, rear, and the new suburbs in the hills beyond.

57. Under the moon of a long night, an igloo glows on the coastal plain of Labrador as a husky stands watch outside.

58. There's a move to have the sturdy and hardy Newfoundland pony recognized as a distinct breed, like the Iceland and the Shetland ponies.

59. Called a *killik*, the wood and stone anchor in the foreground is said to have been in use since Viking times and is still common, both in full size and miniature souvenir versions.

60. Rocky Ramea, on an island off the south coast, clings to the bedrock which was left when glaciers ploughed a thick top layer of Newfoundland into the sea to form that vast and fertile shoal known as the Grand Banks.

61. Port de Grave is one of several historic fishing towns in Conception Bay with a long tradition of both the inshore fishery and the summer fishery off Labrador.

62. Dories (this one motorized) can bear a ton or more of cargo, have no more draft than a canoe and yet are seaworthy hundreds of miles off shore. Standard and proper dress is a shade of yellow known as *dory buff*.

63. On a narrow shelf between cliffs and sea is Francois, on the south coast, still accessible only by boat or helicopter. A helicopter pad is a recent feature of many isolated settlements.

64. Outboard motors co-exist with the old *one-lungers* on small craft in many outports.

65. Sunset over saltbox houses along the coast of Conception Bay.

66. A typical style of architecture in the outports is the cube or *foursquare* house which followed the earlier saltbox and gable.

67. A small boat at her mooring in a sunset over Conception Bay.

68. Misty morning in a cove, Conception Bay.

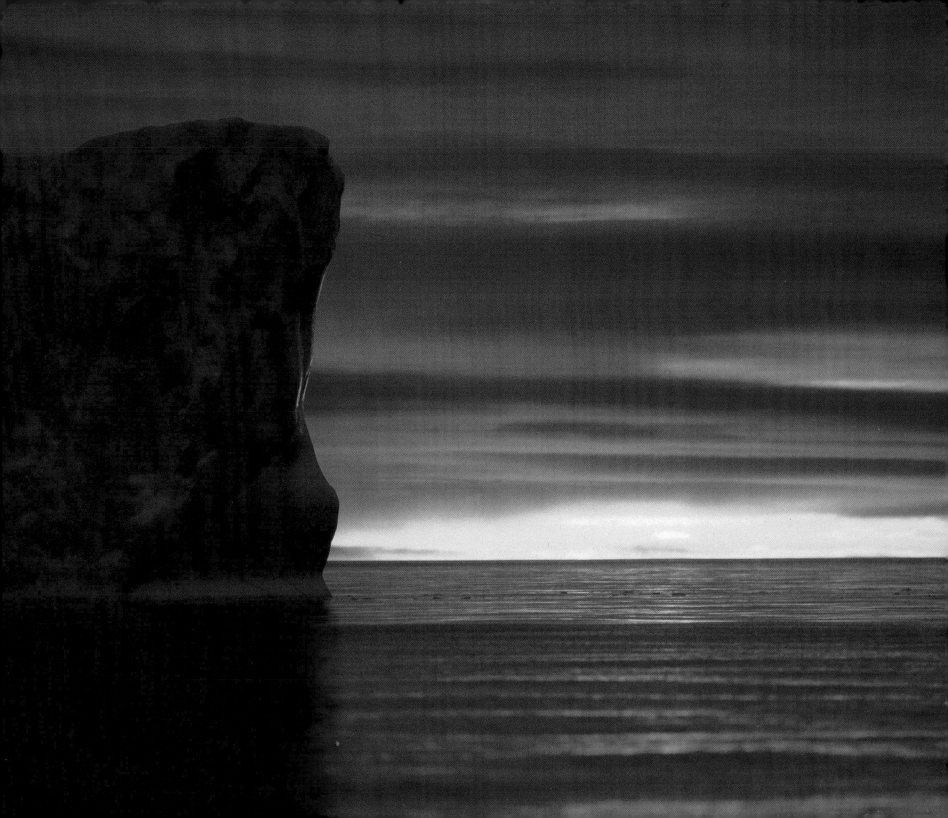

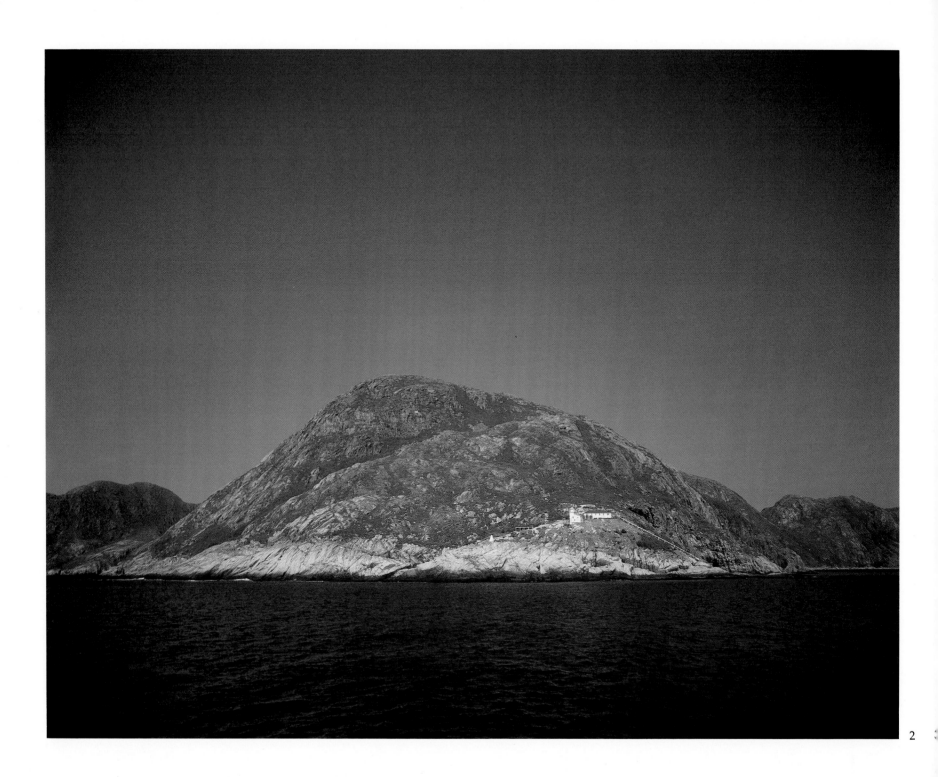

2

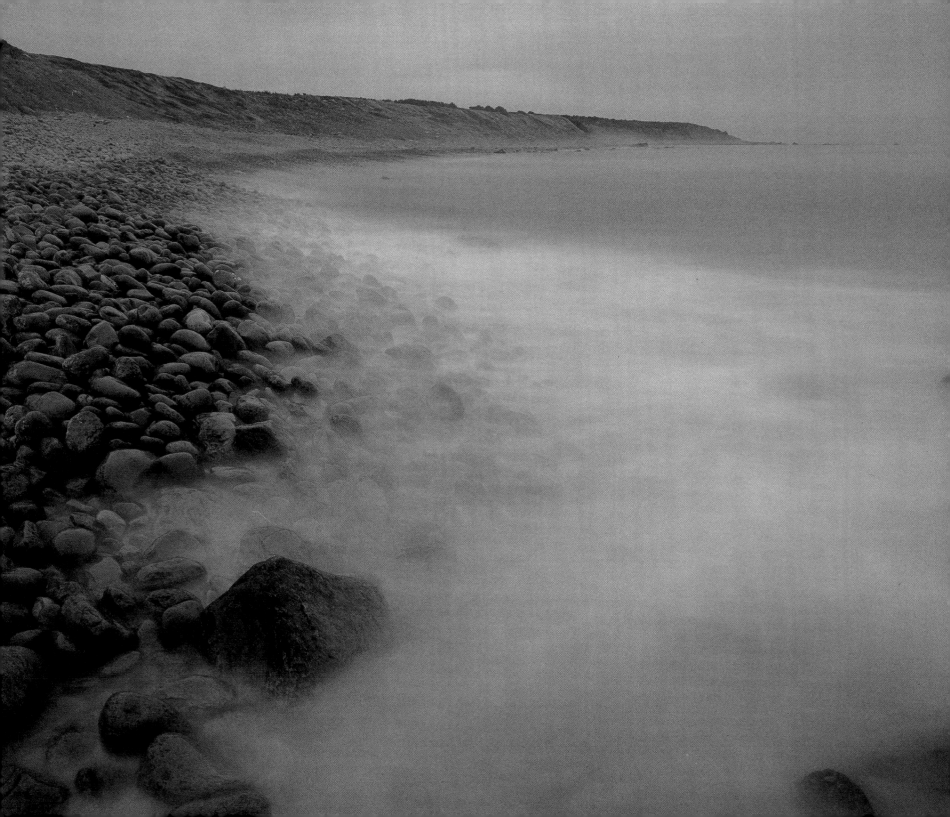

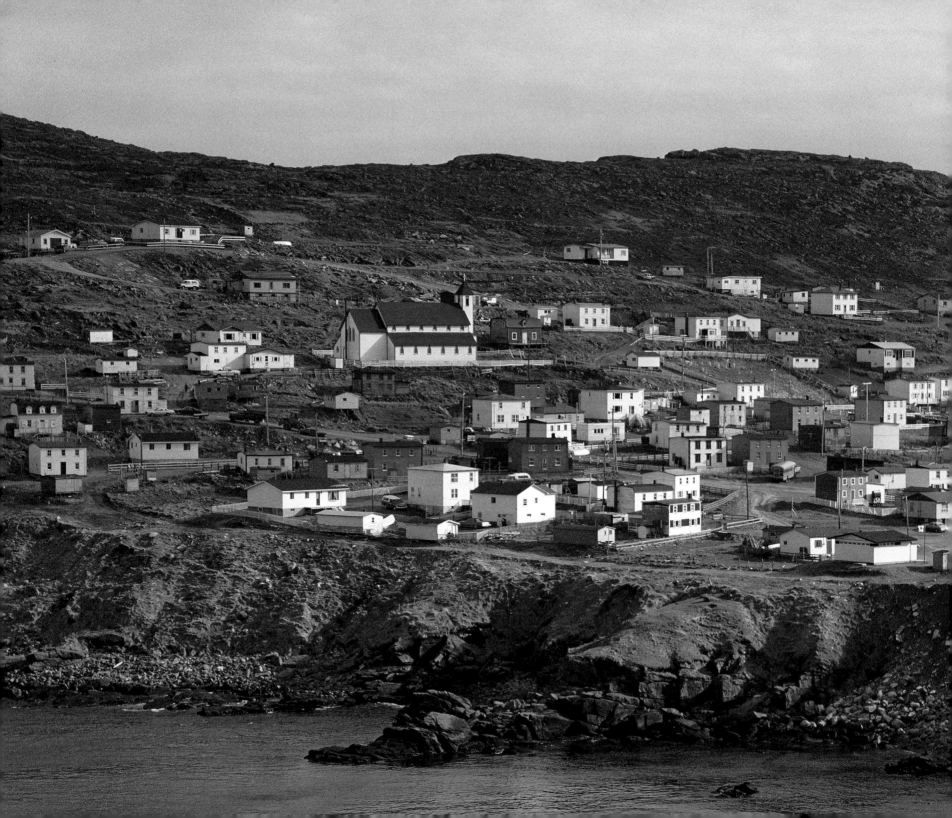

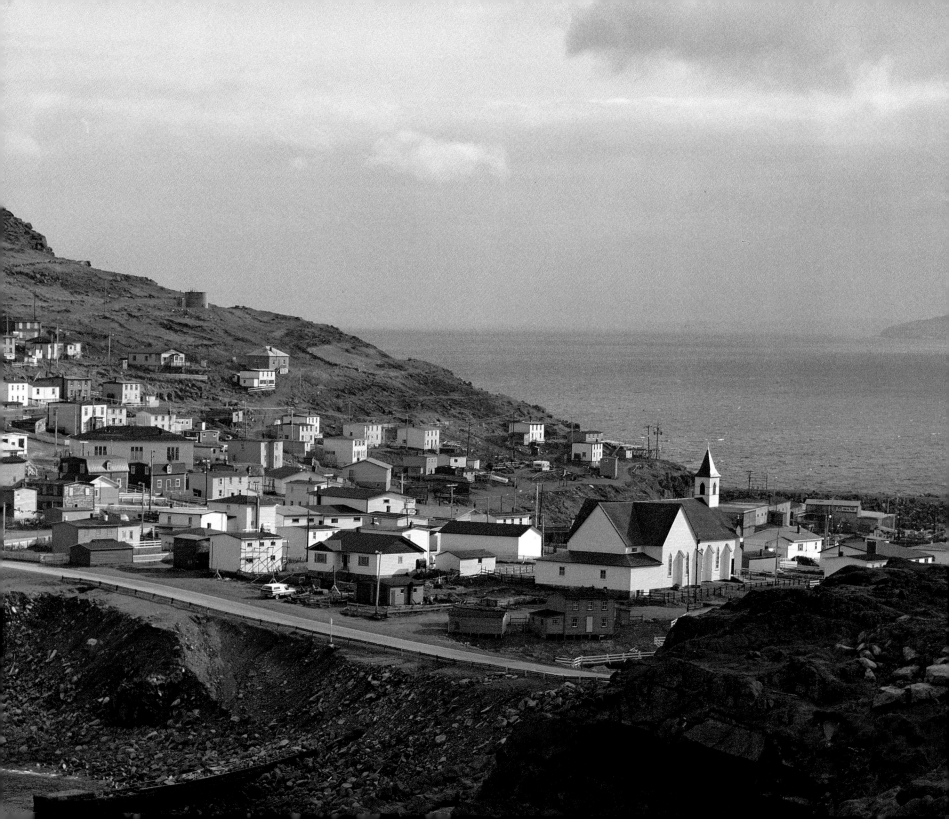

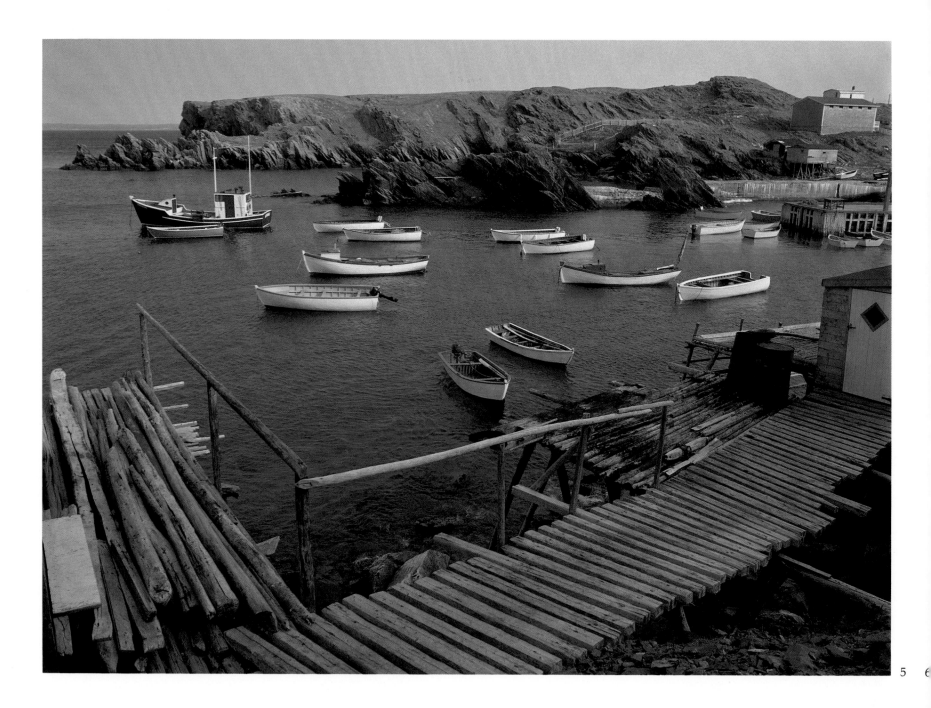

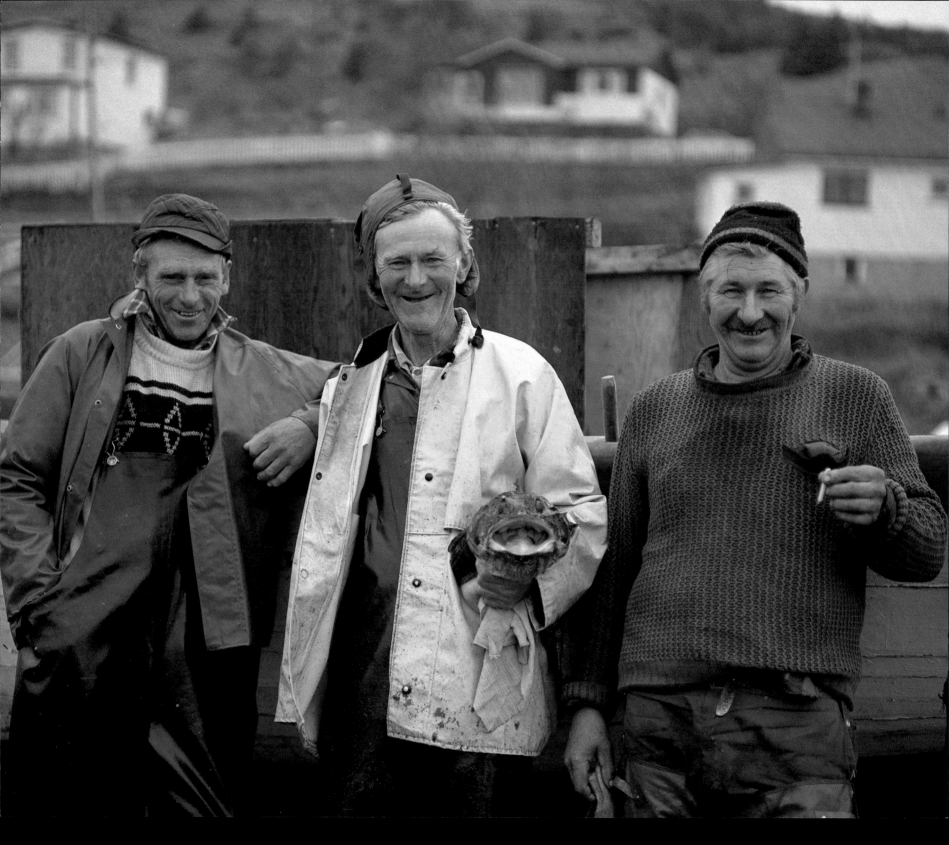

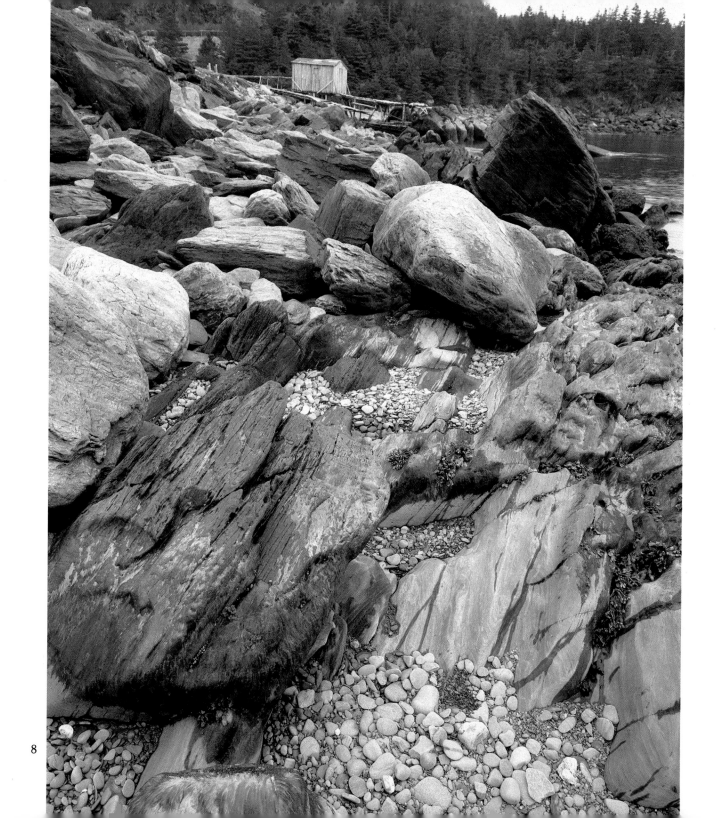

8

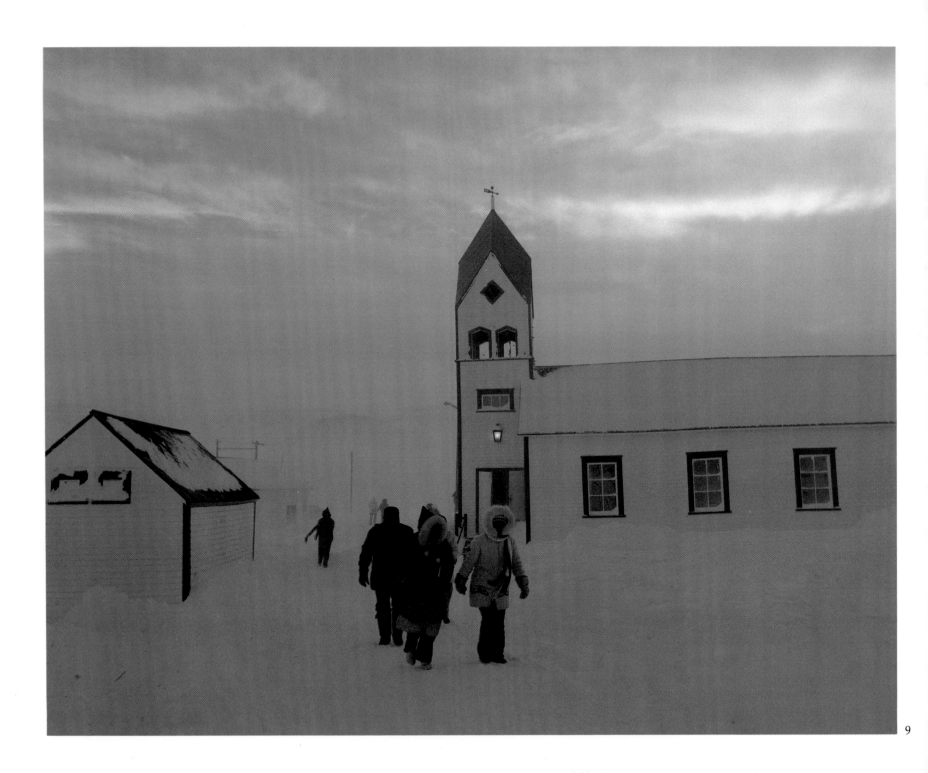

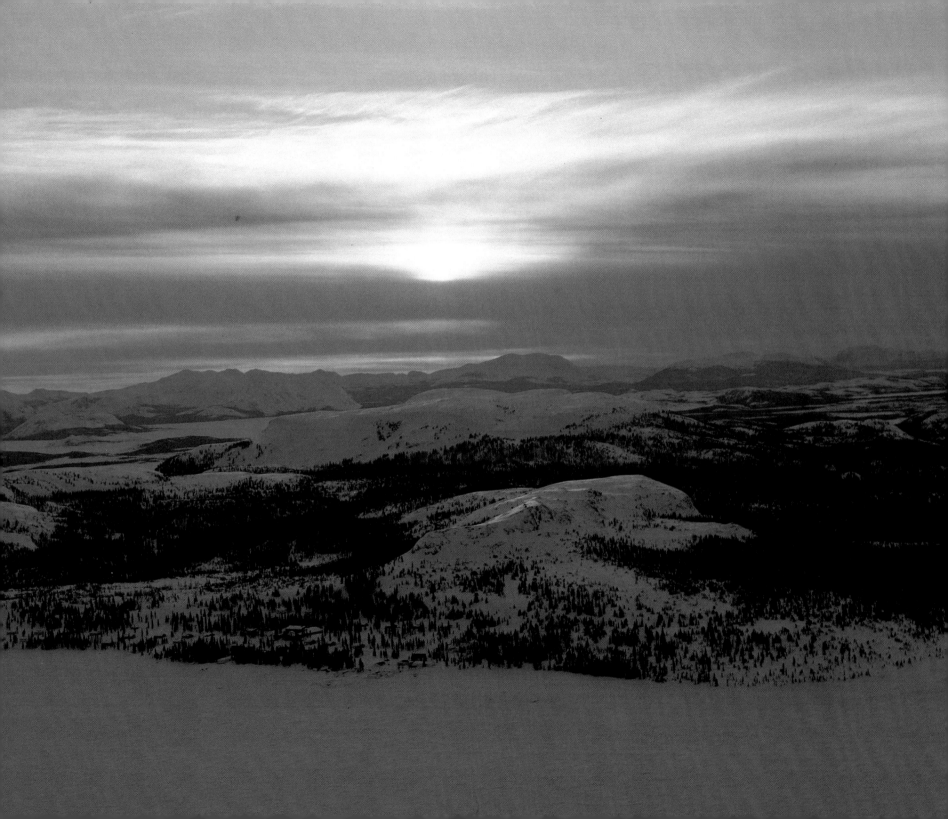

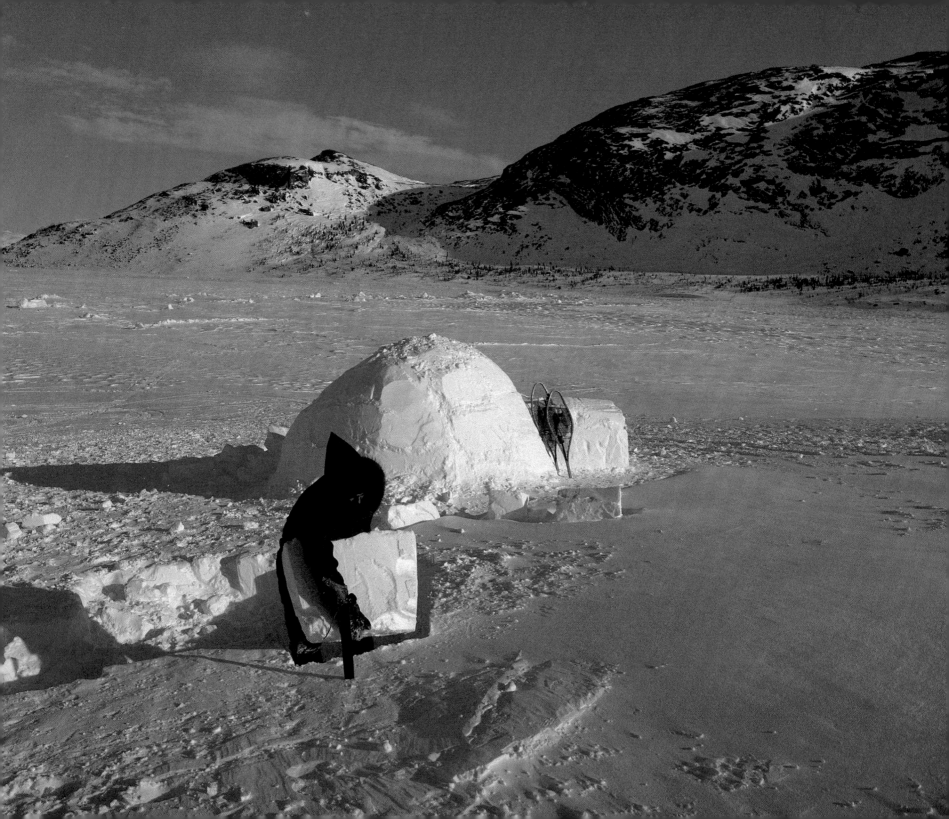

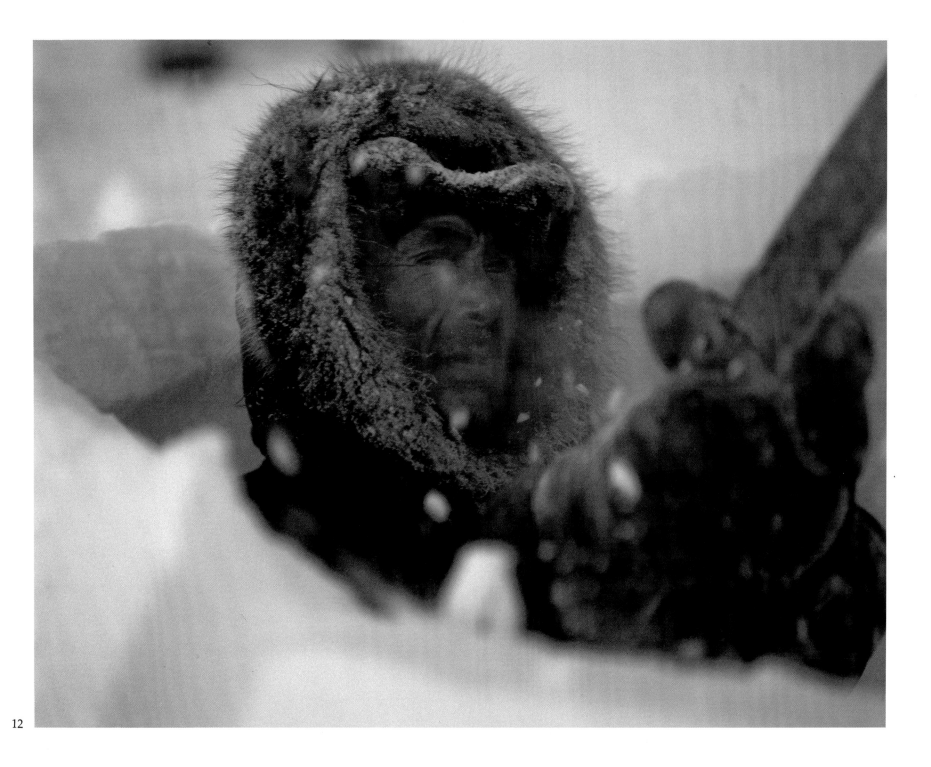

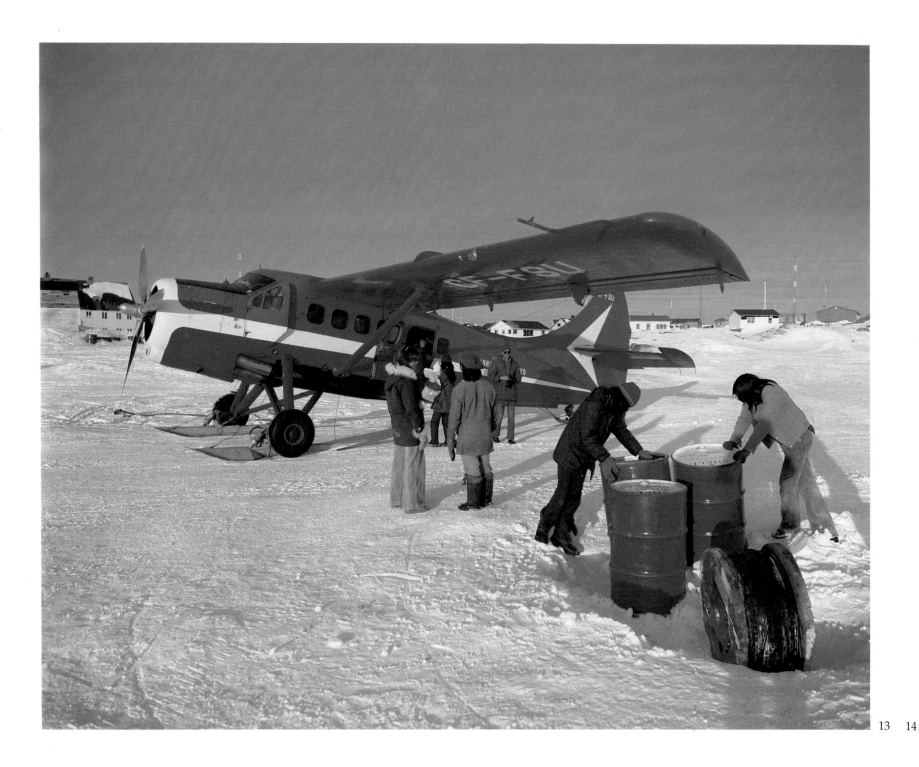

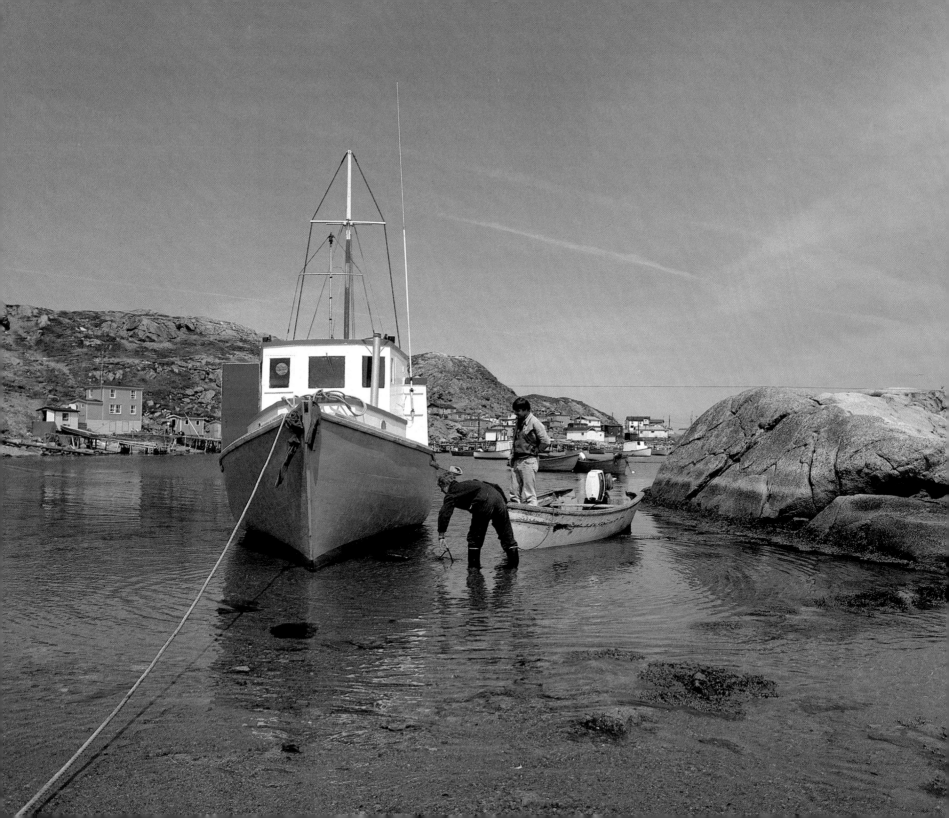

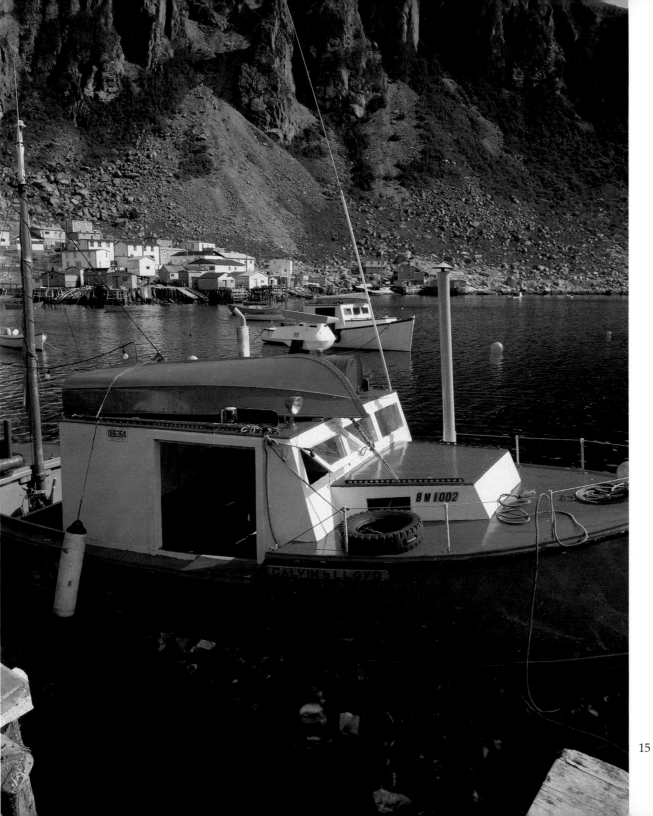

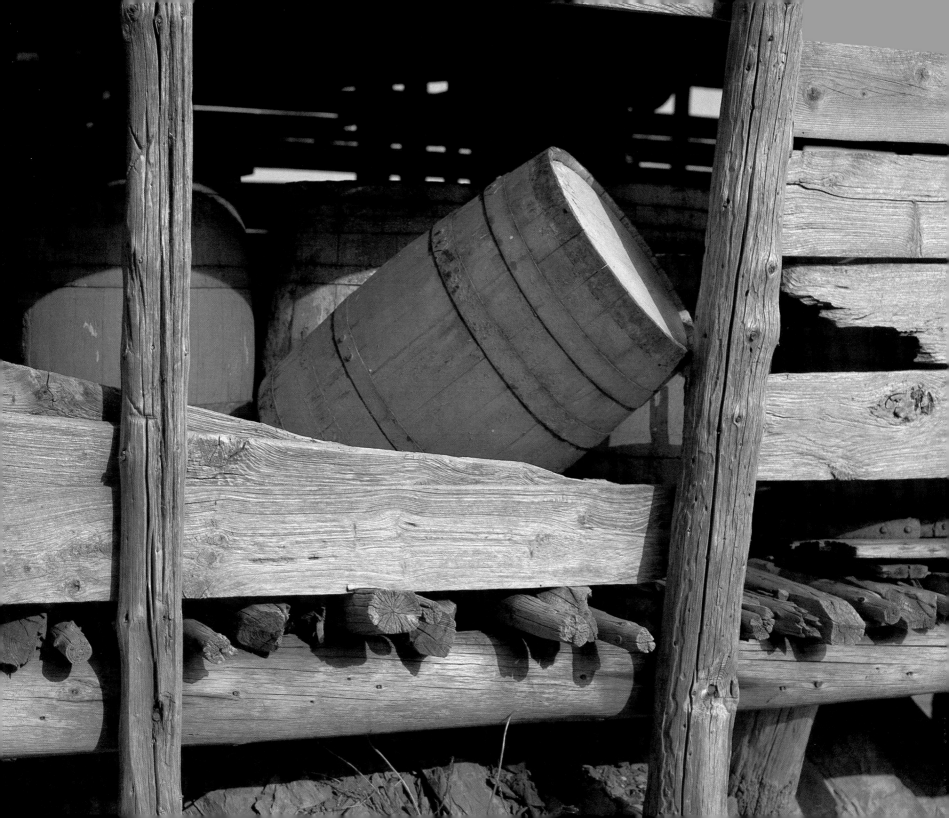

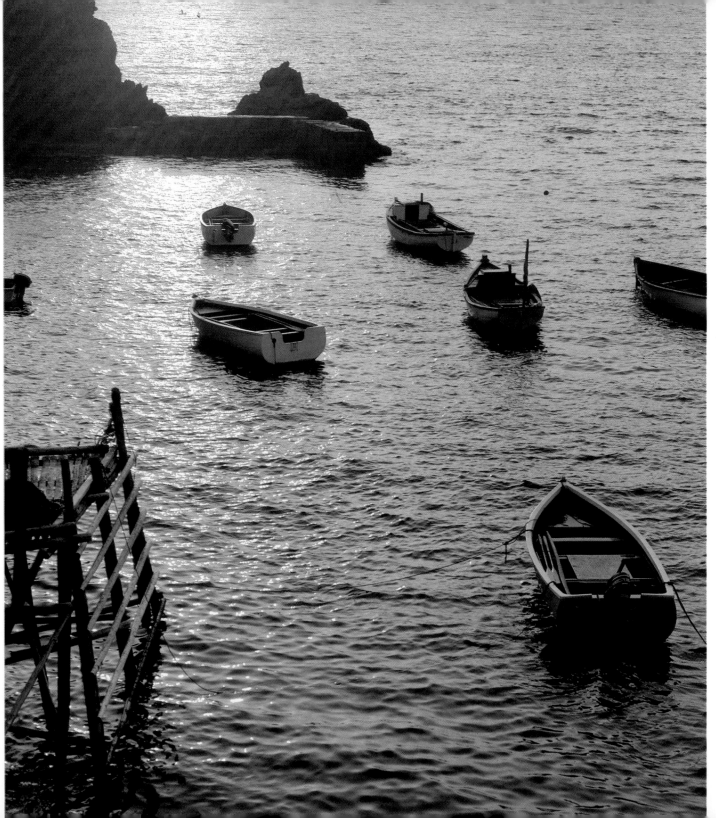

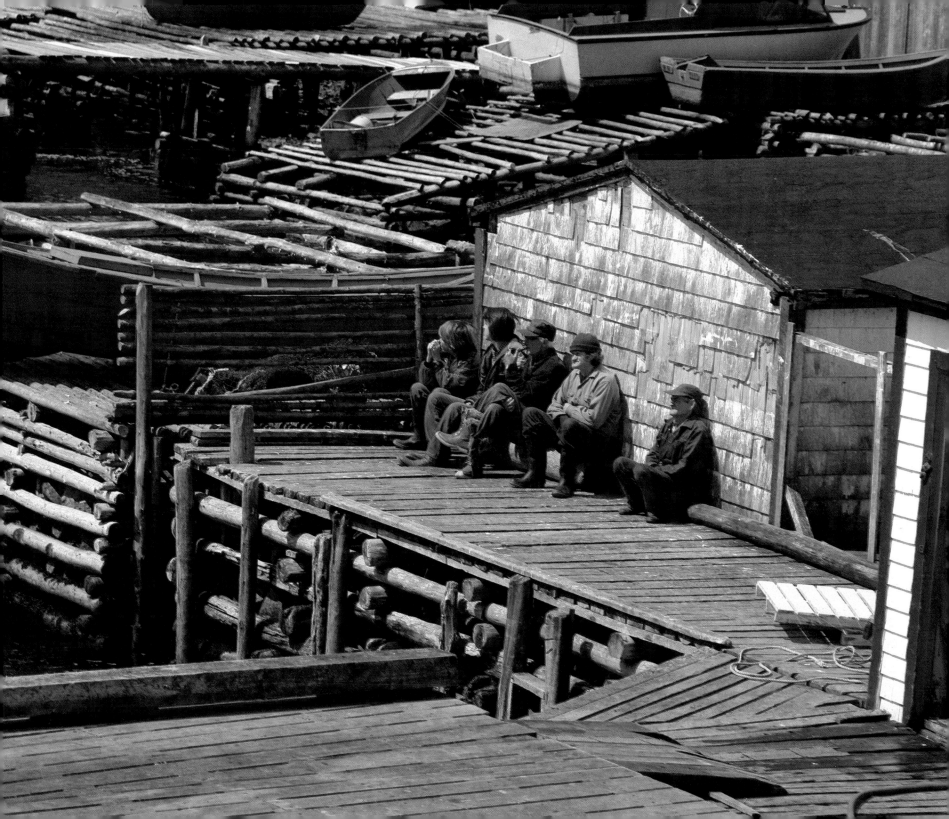

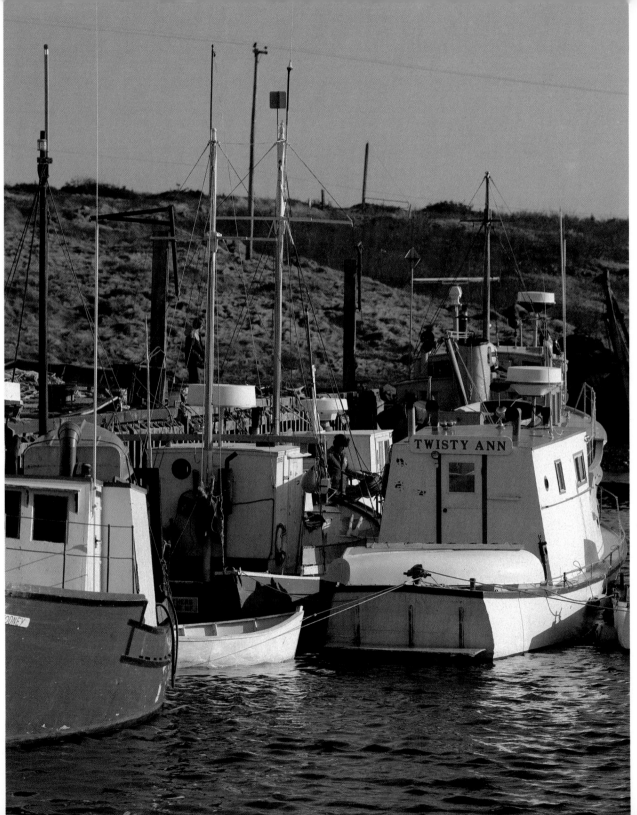

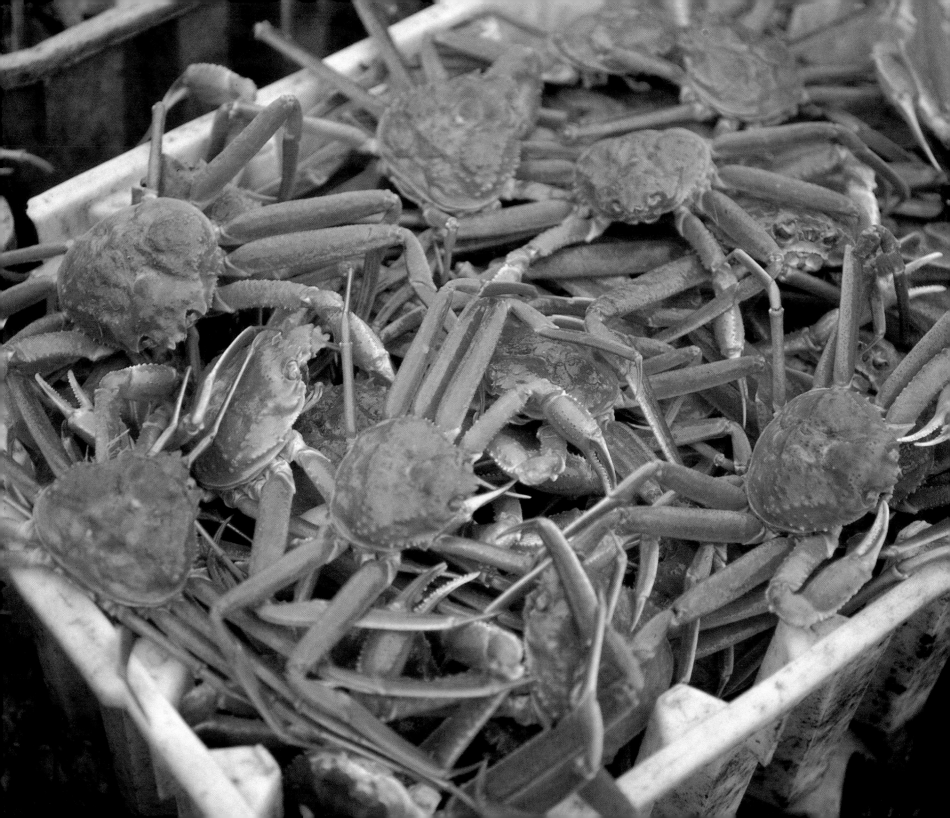

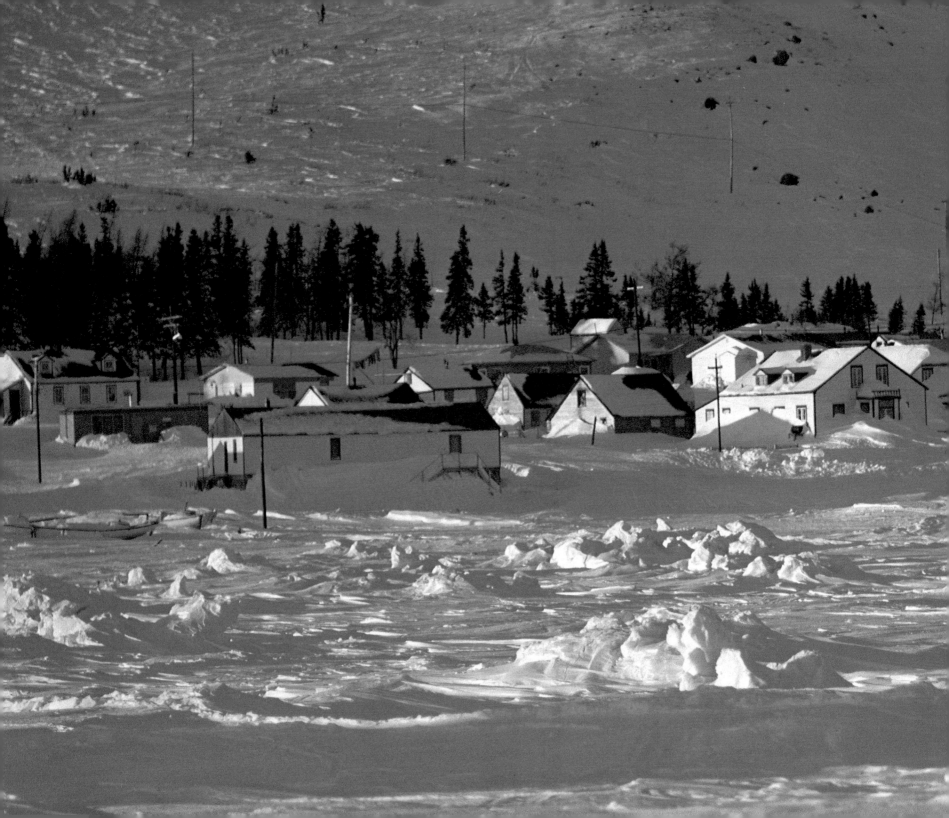

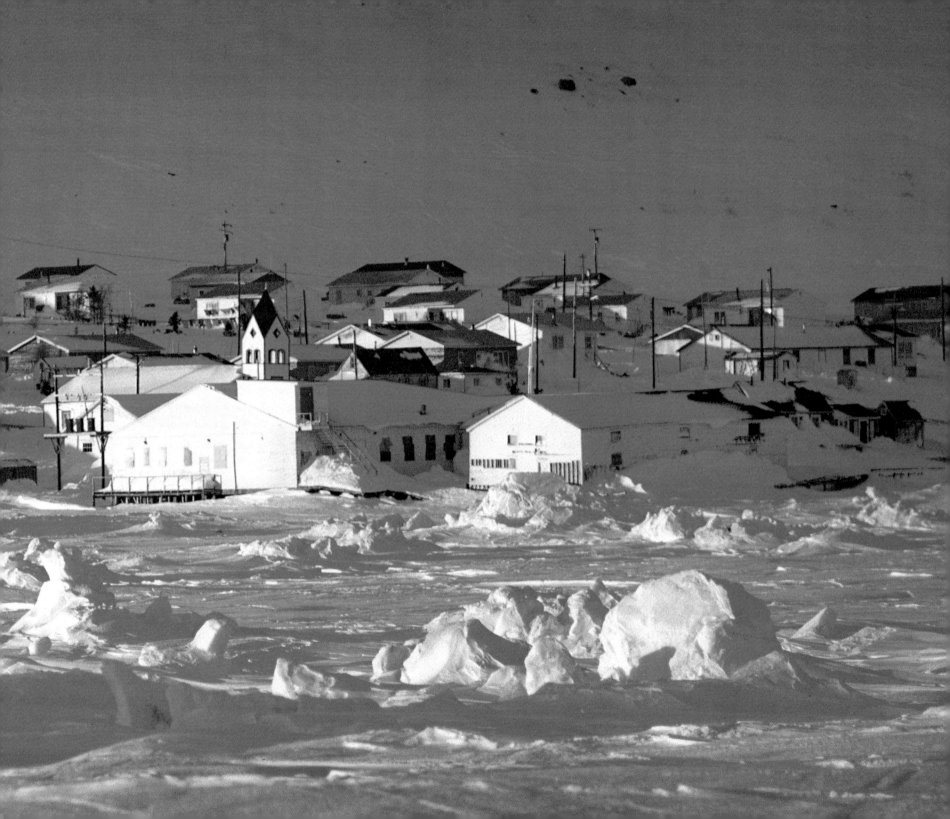

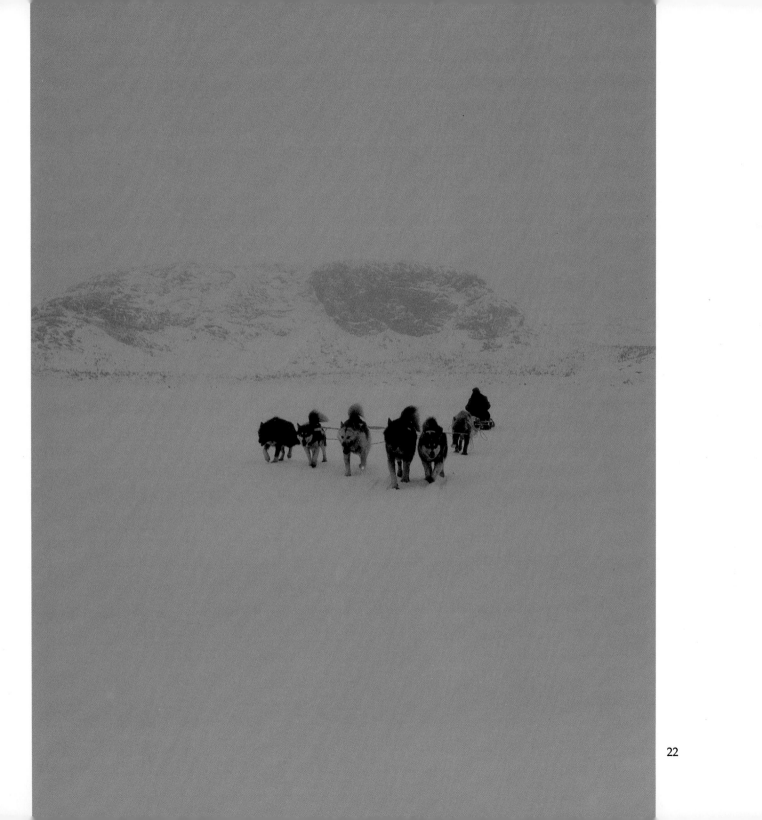

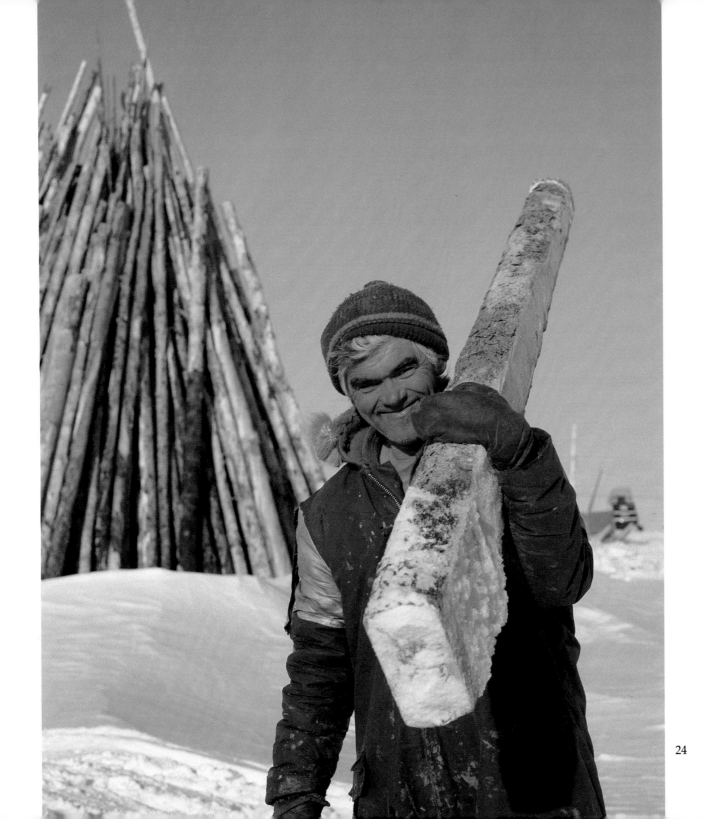

24

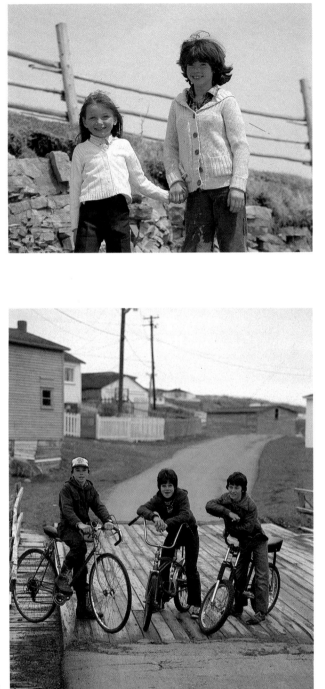

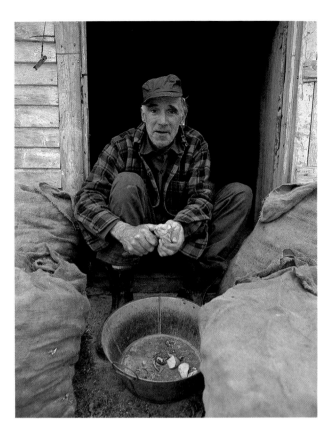

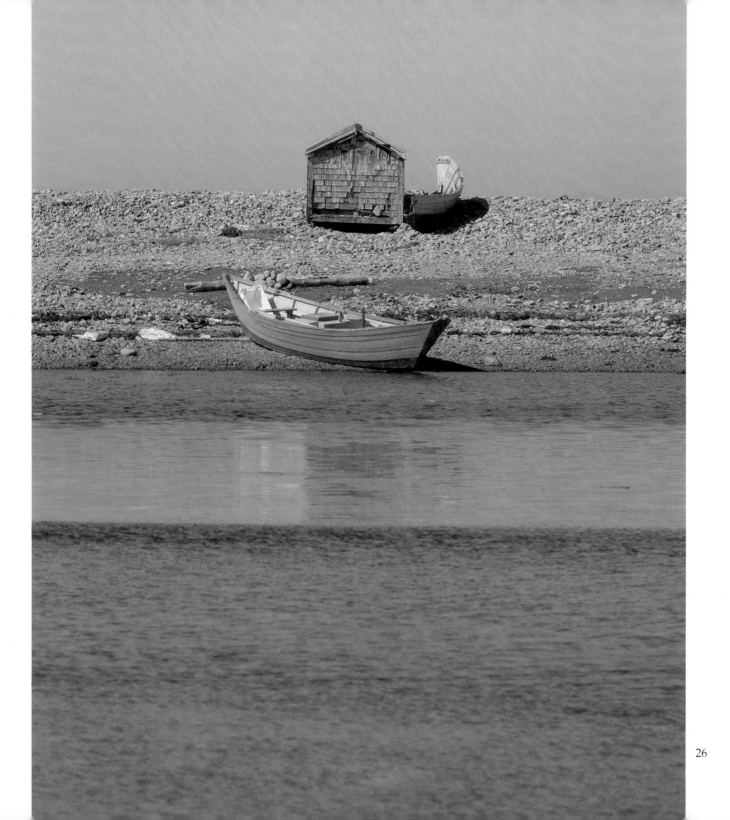

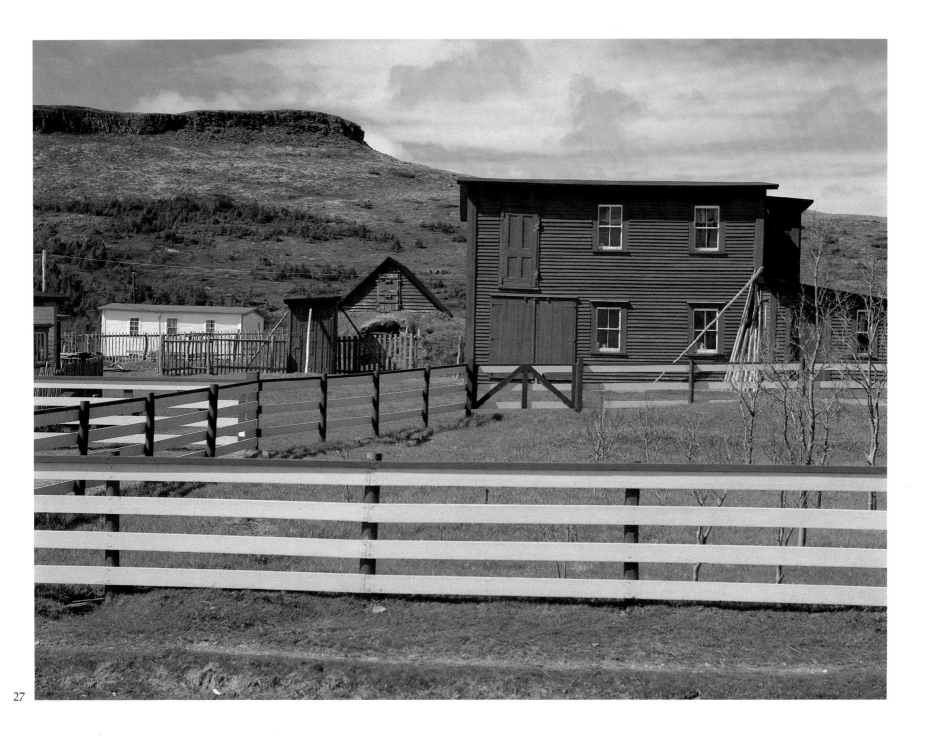

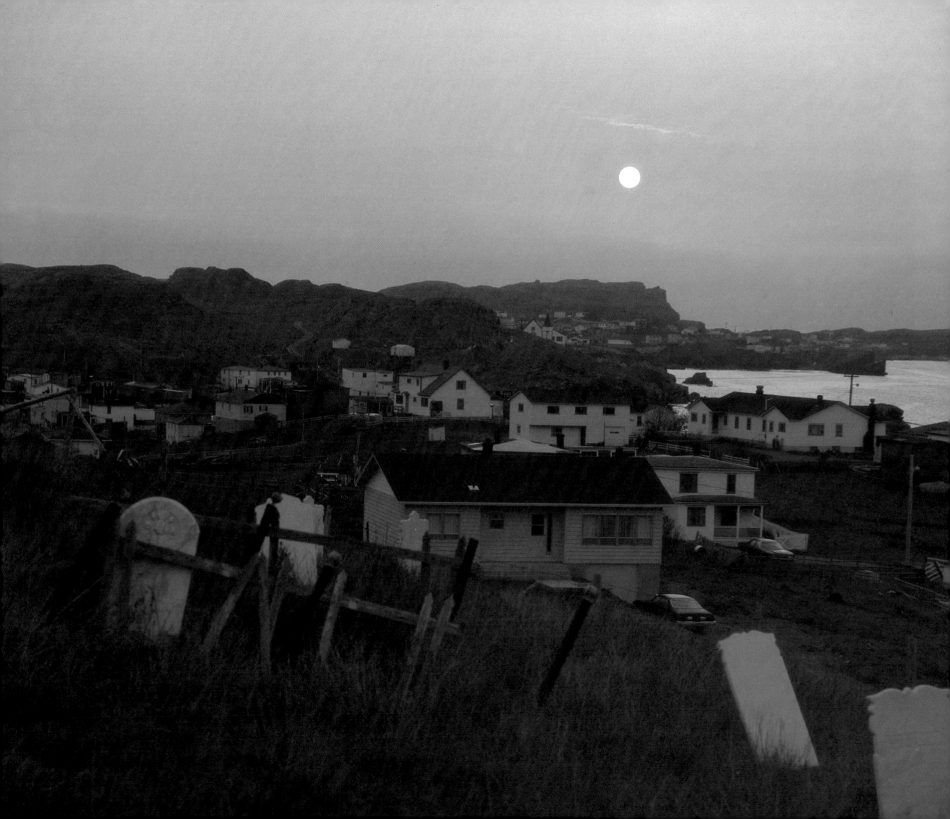

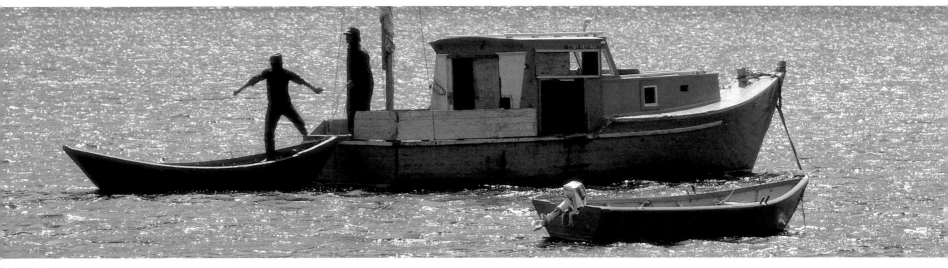

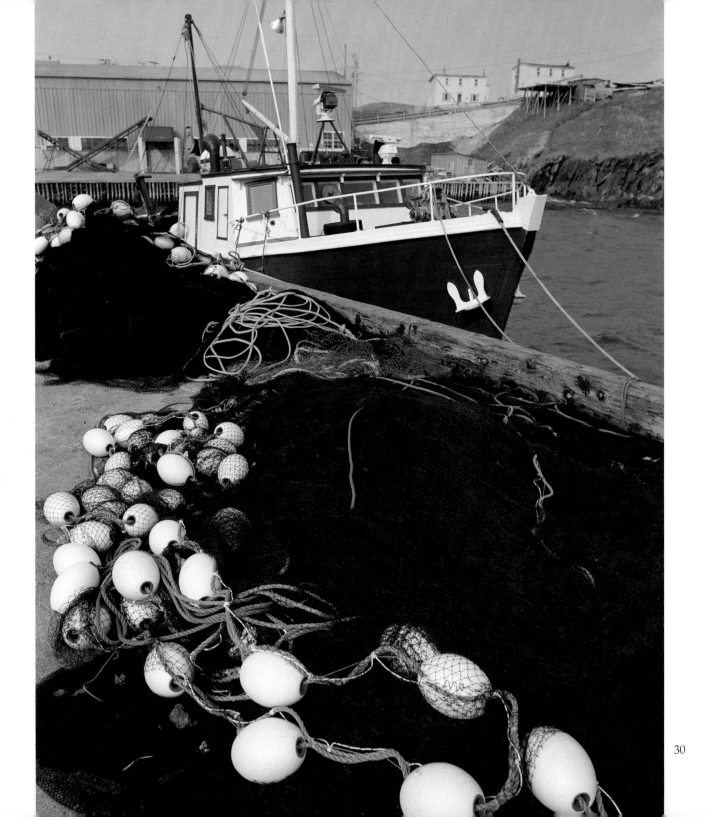

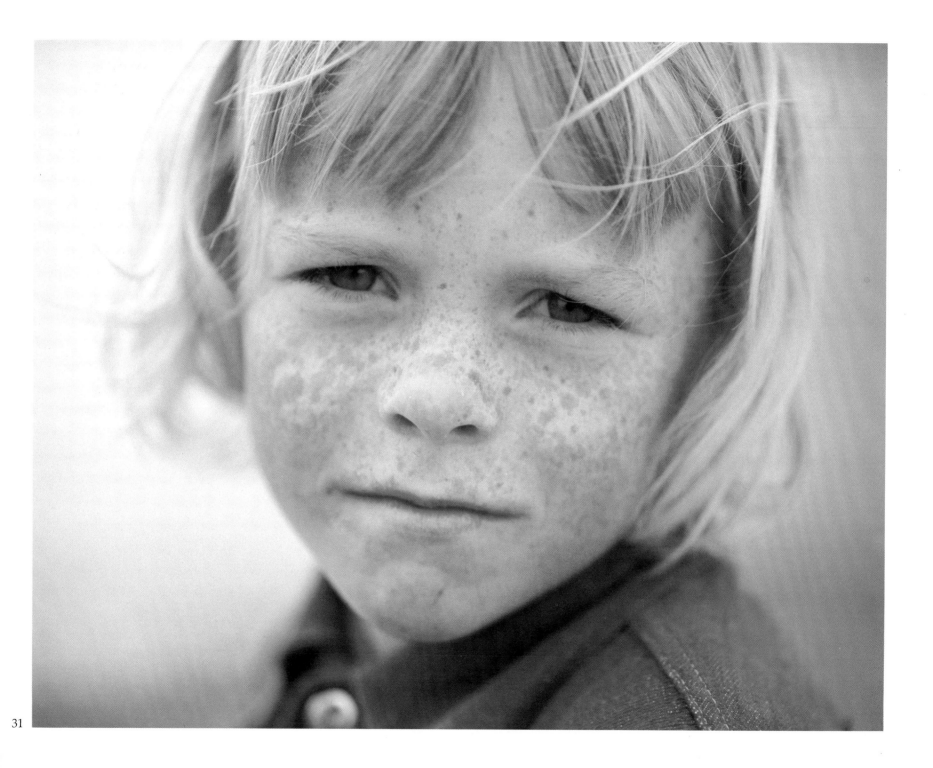

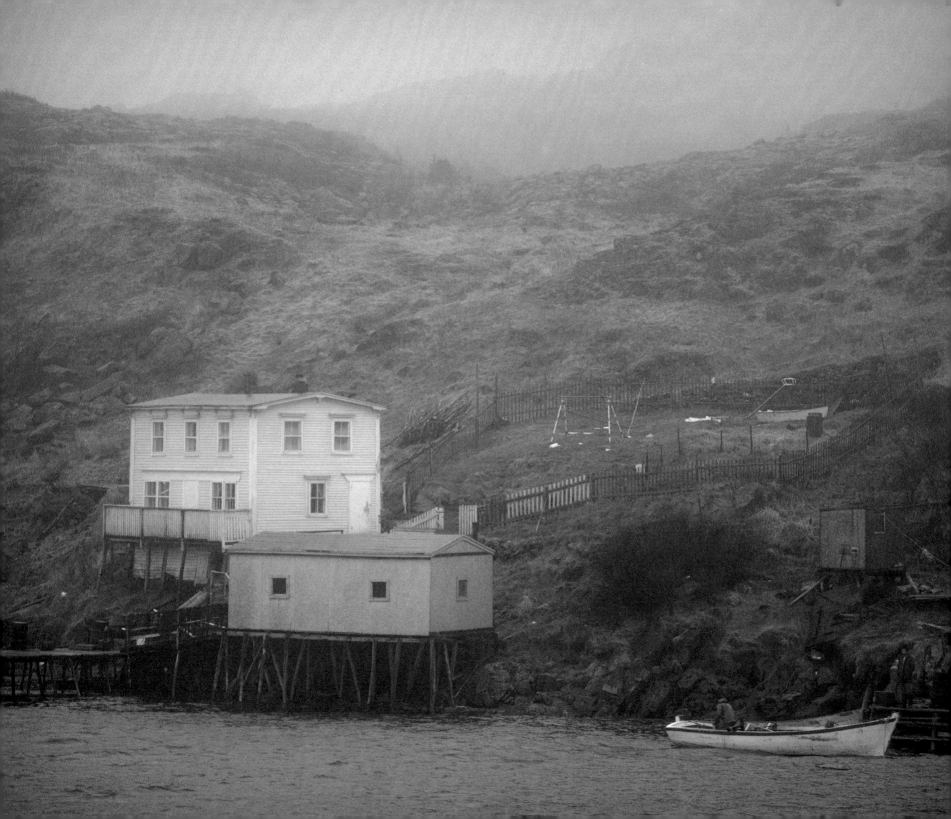

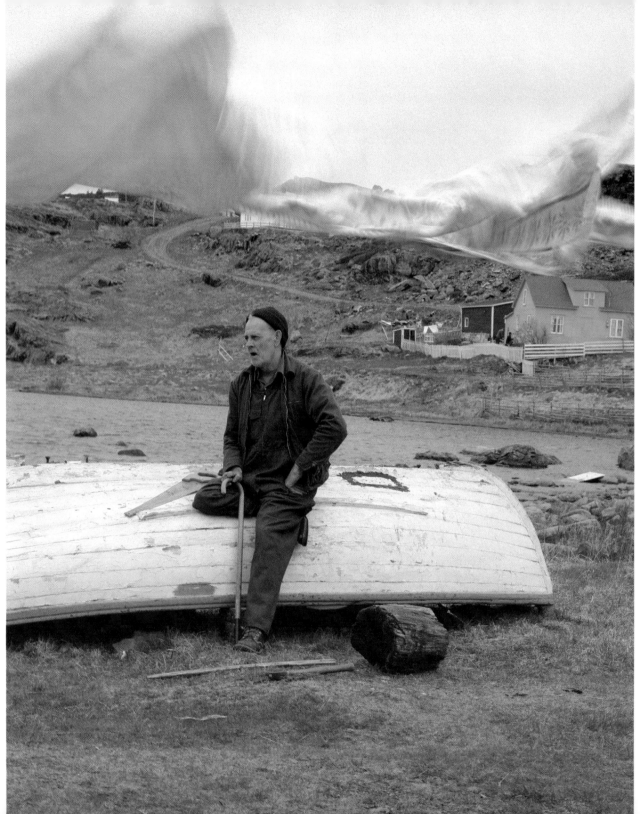

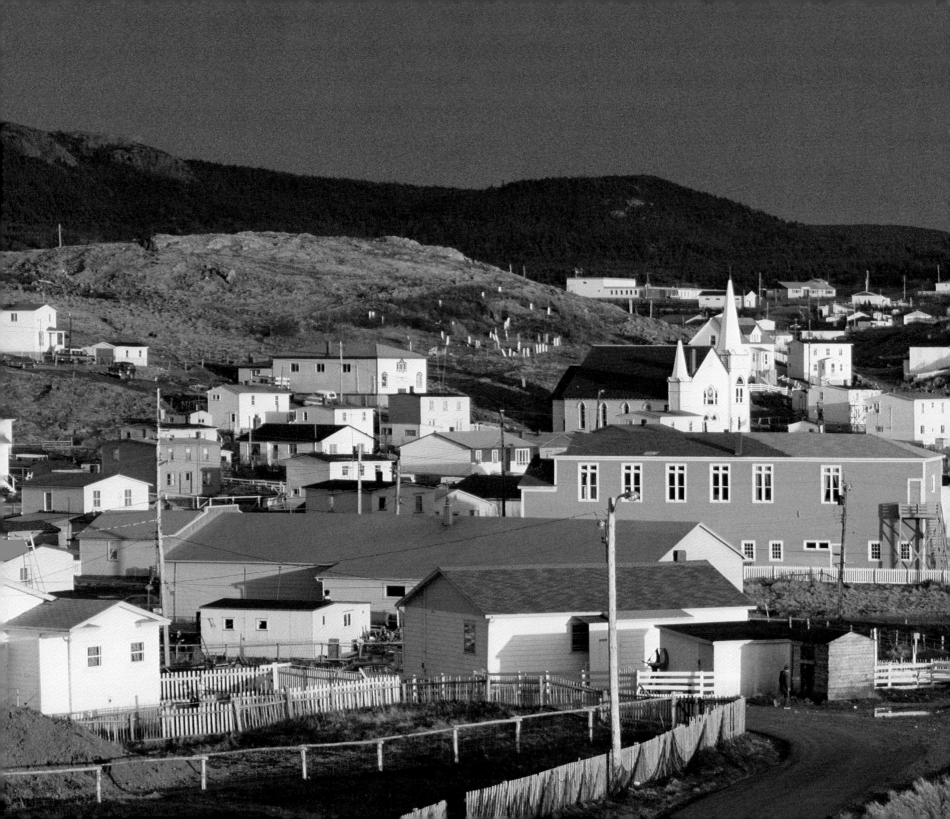

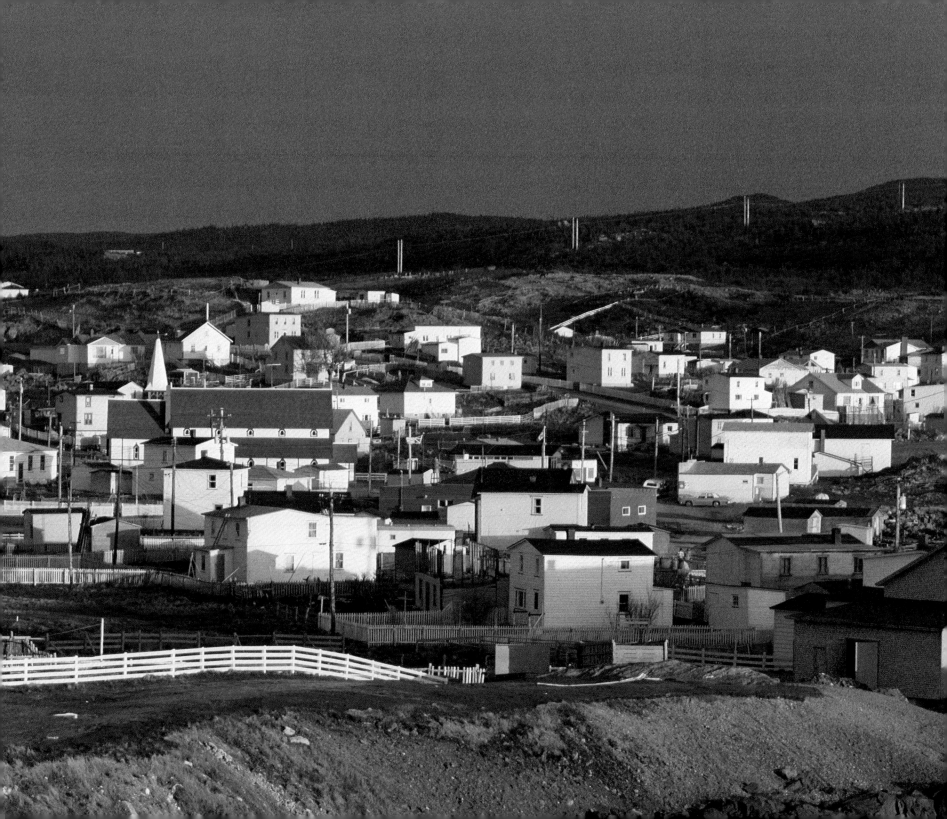

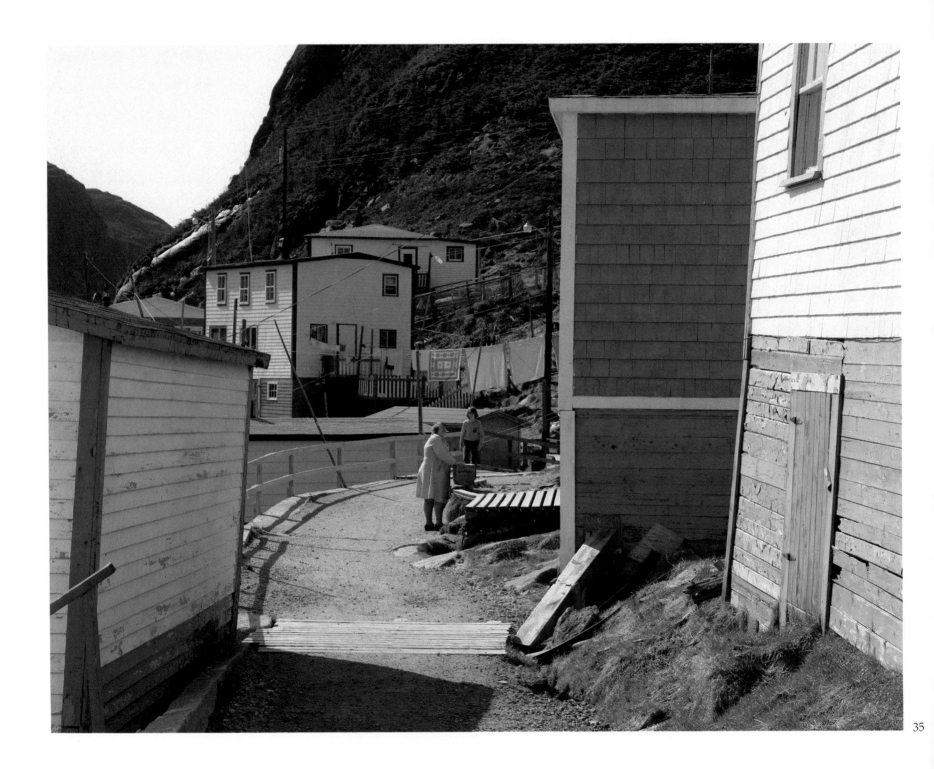

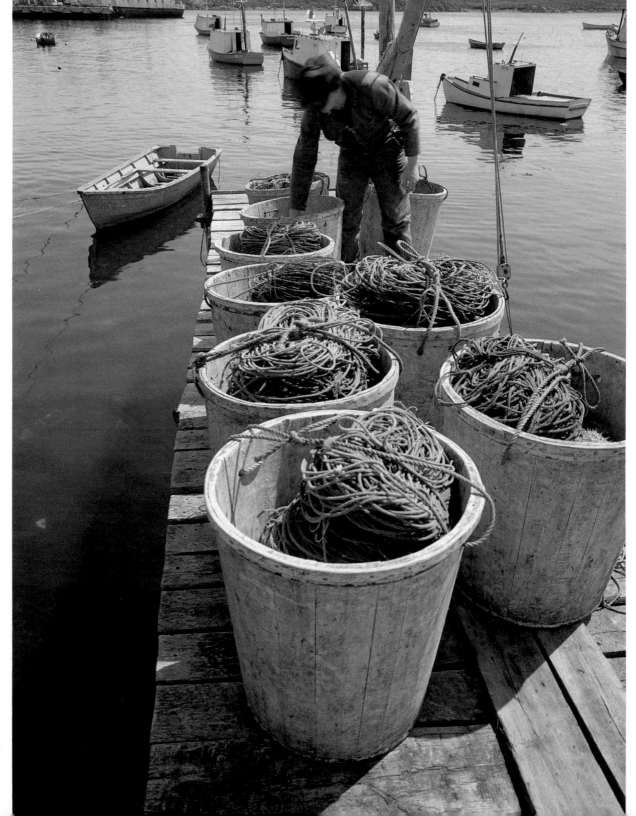

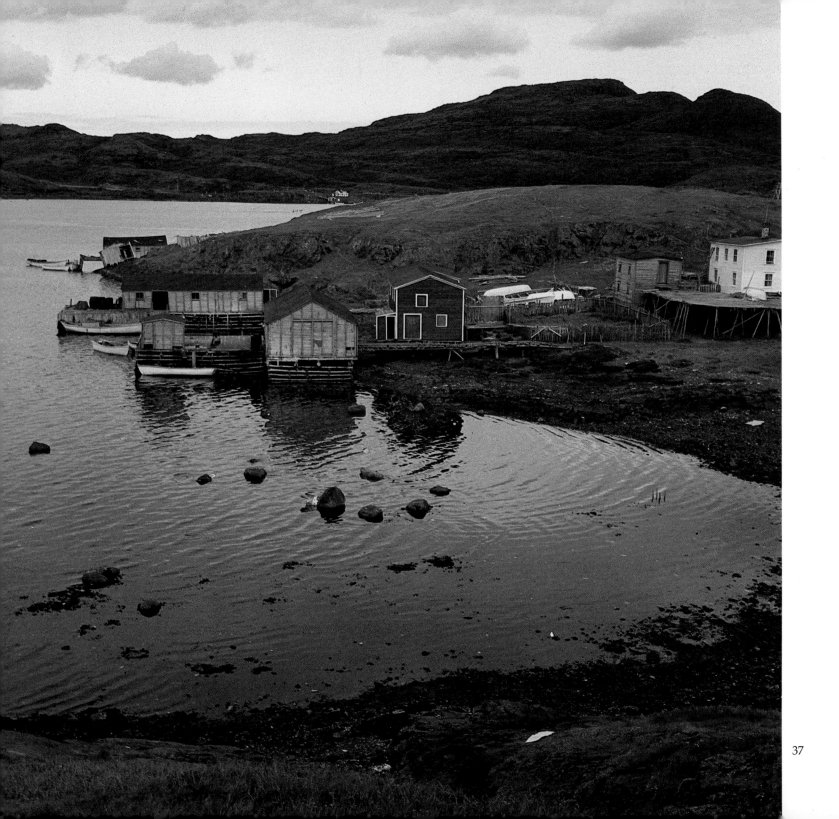

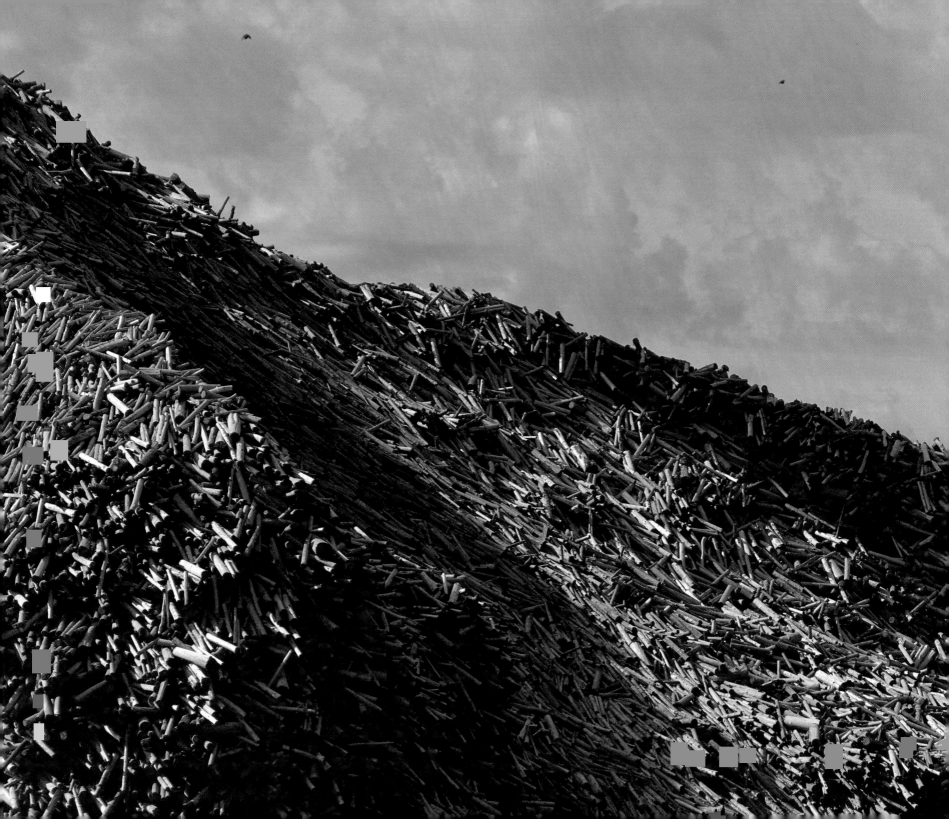

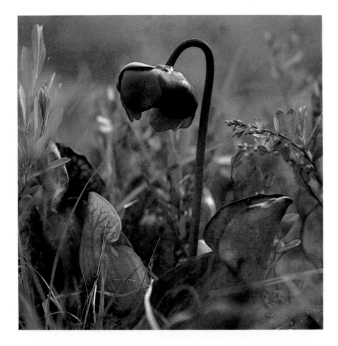 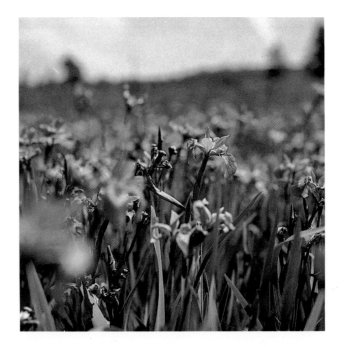

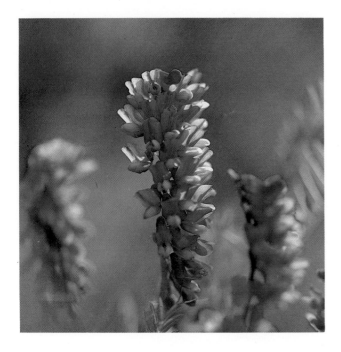 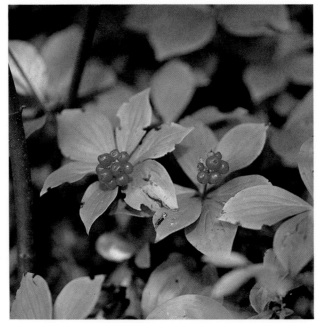

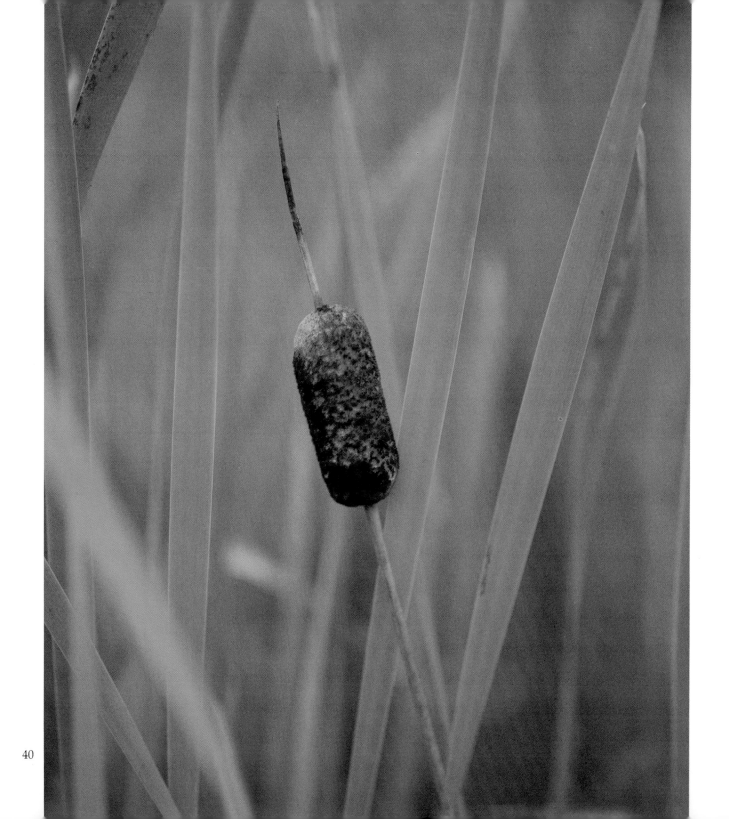

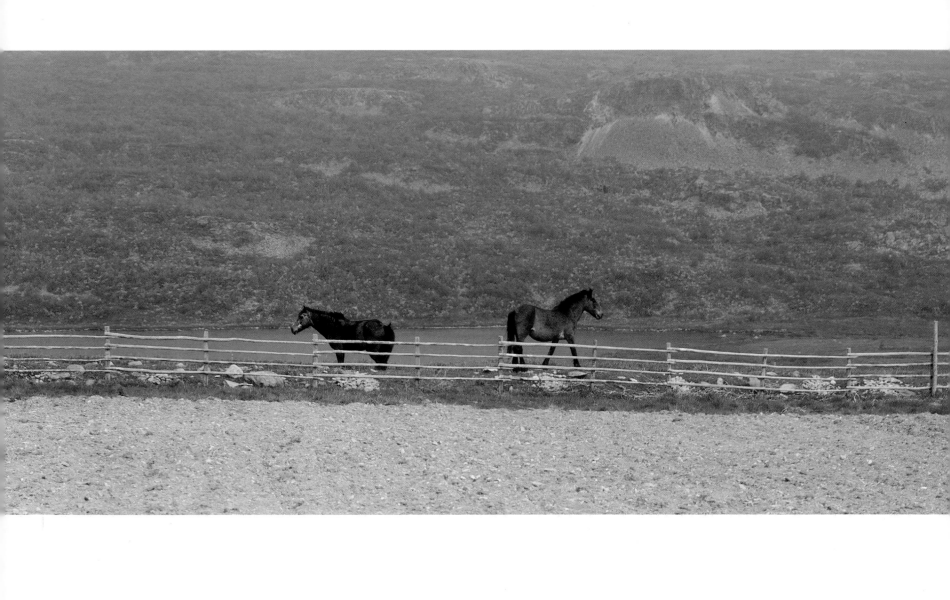

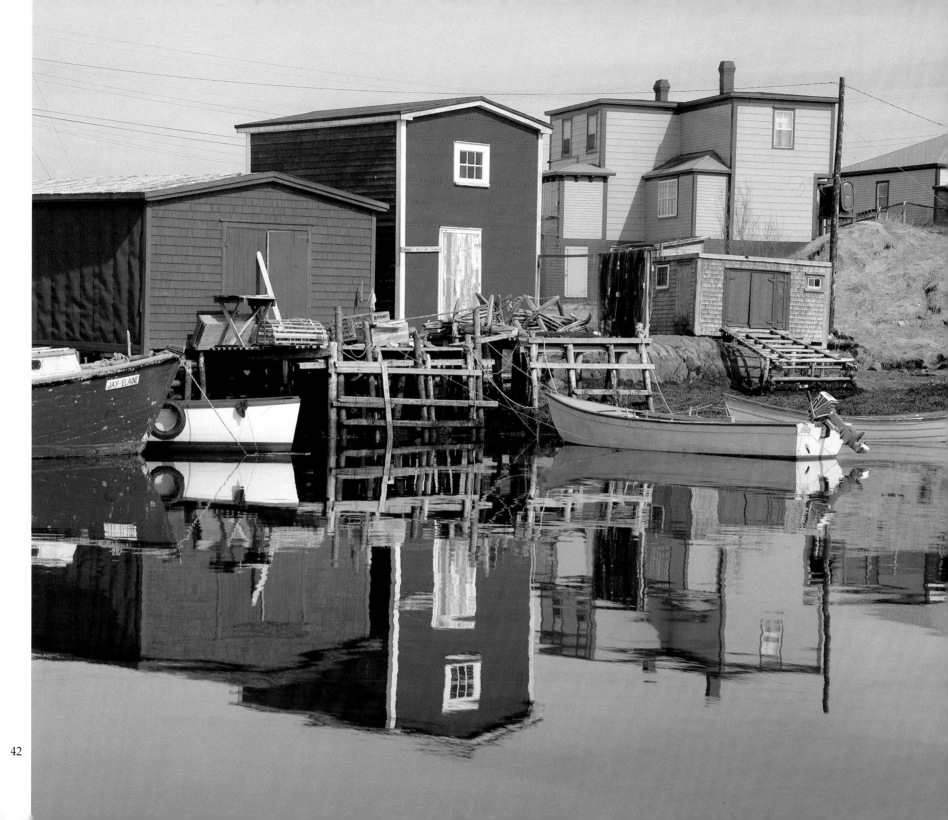

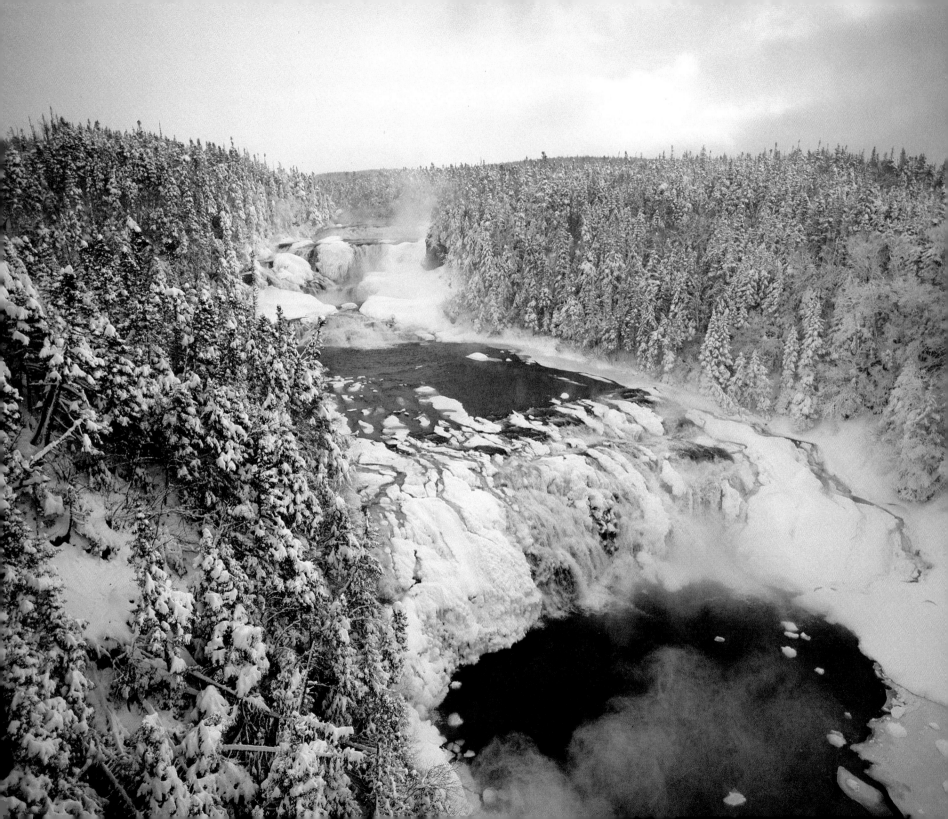

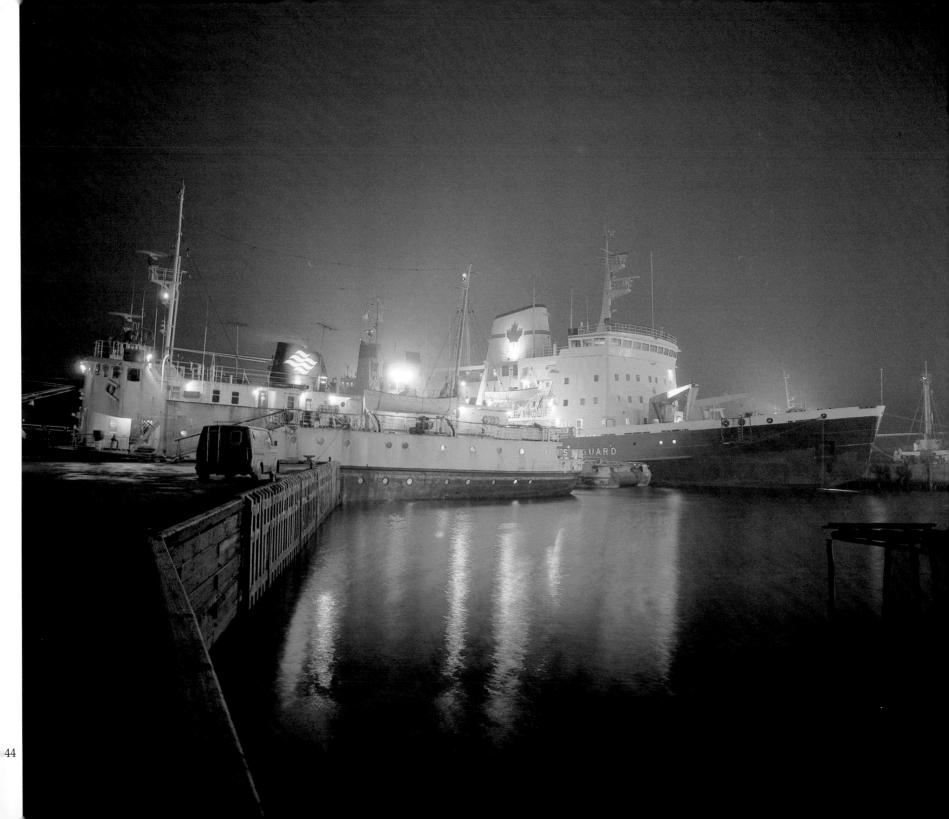

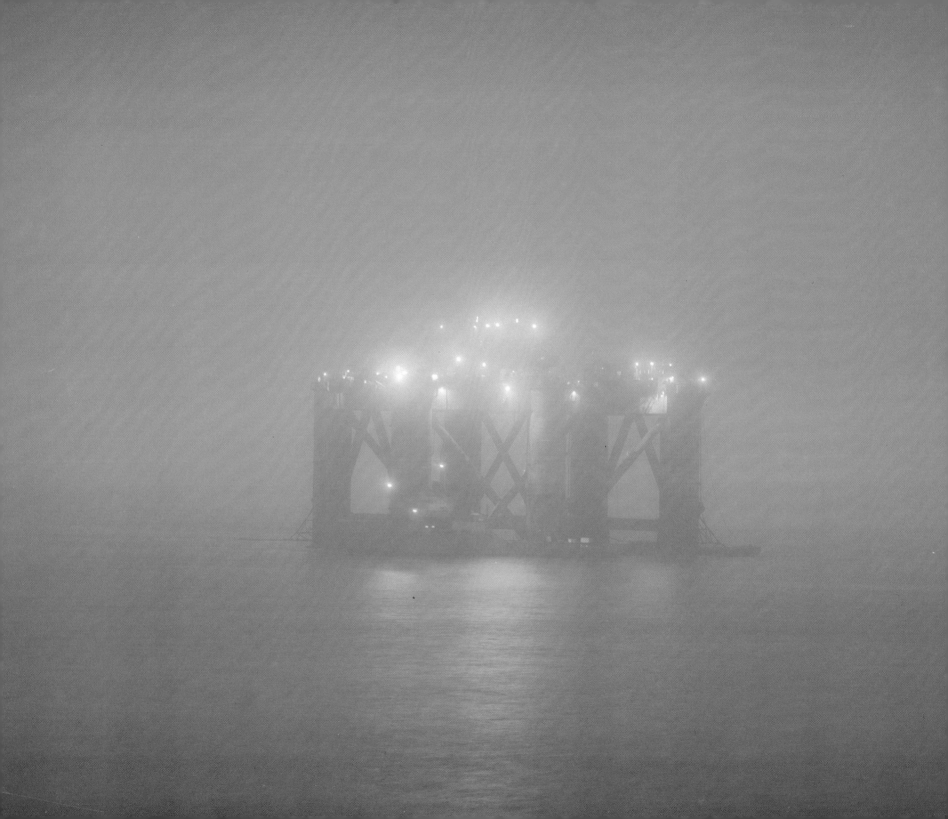

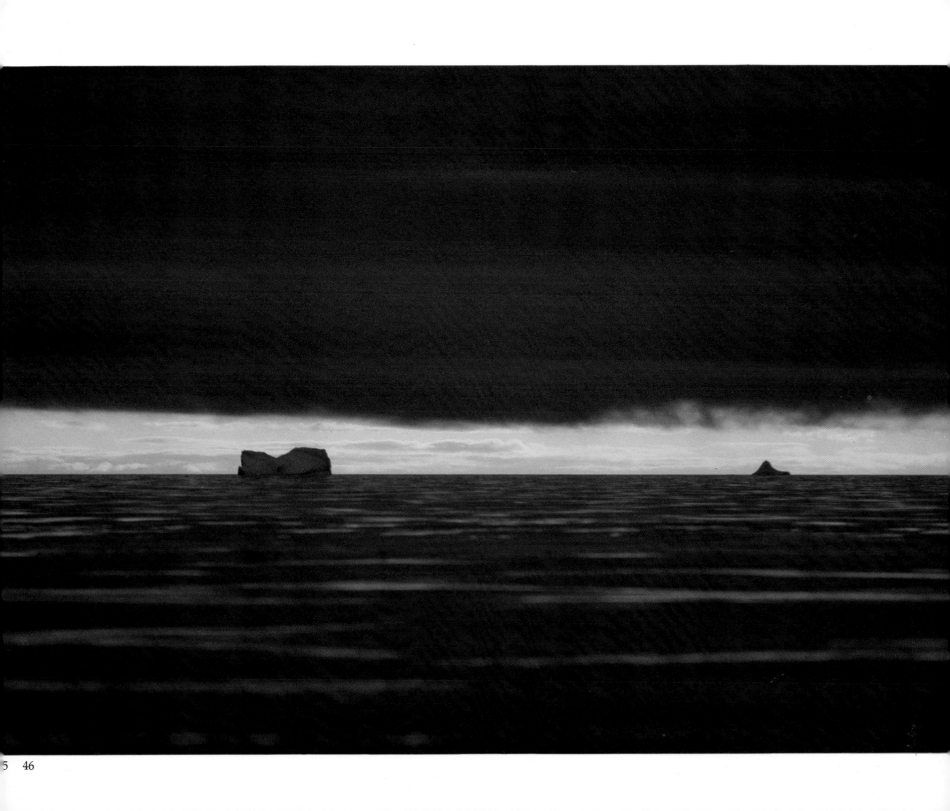

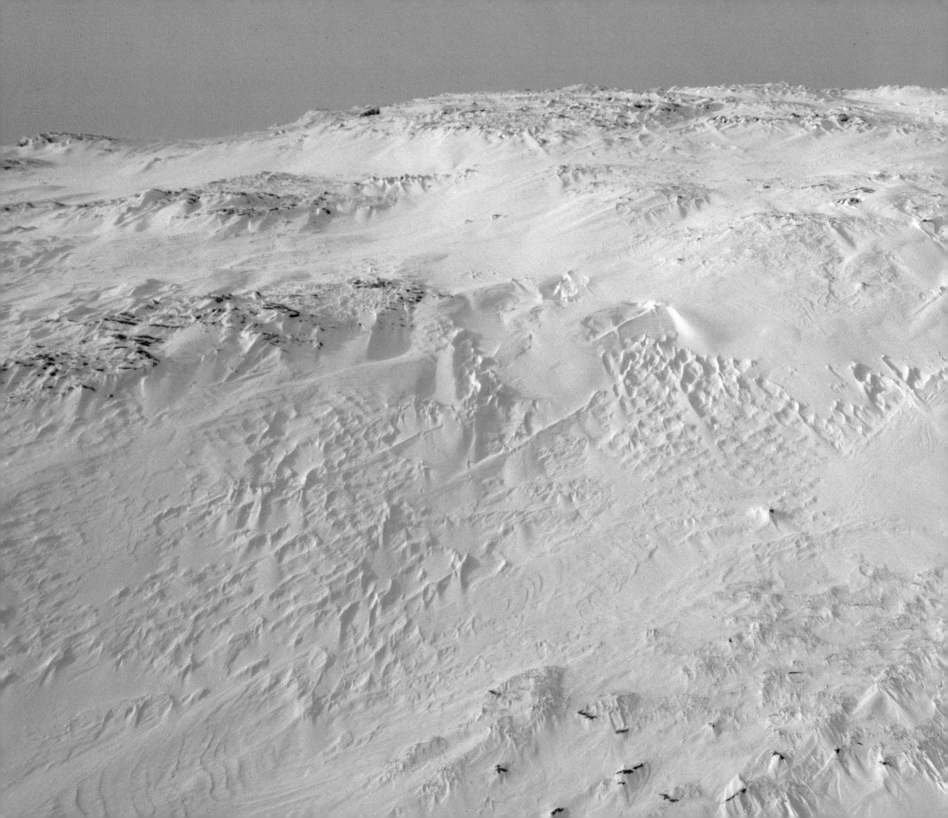

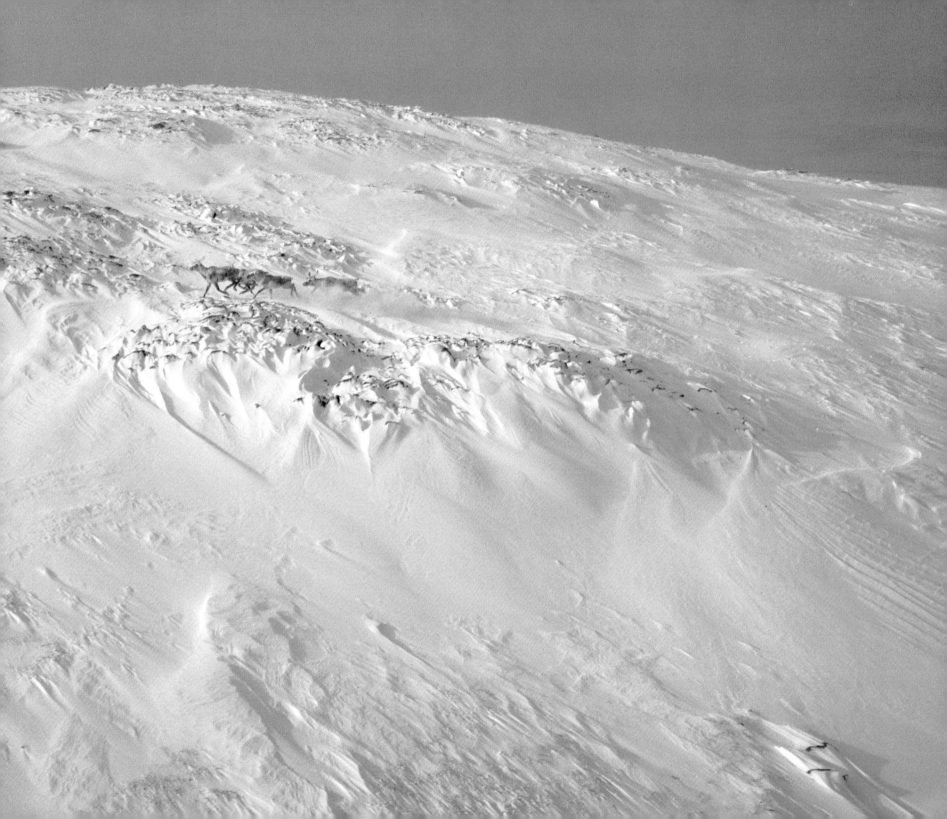

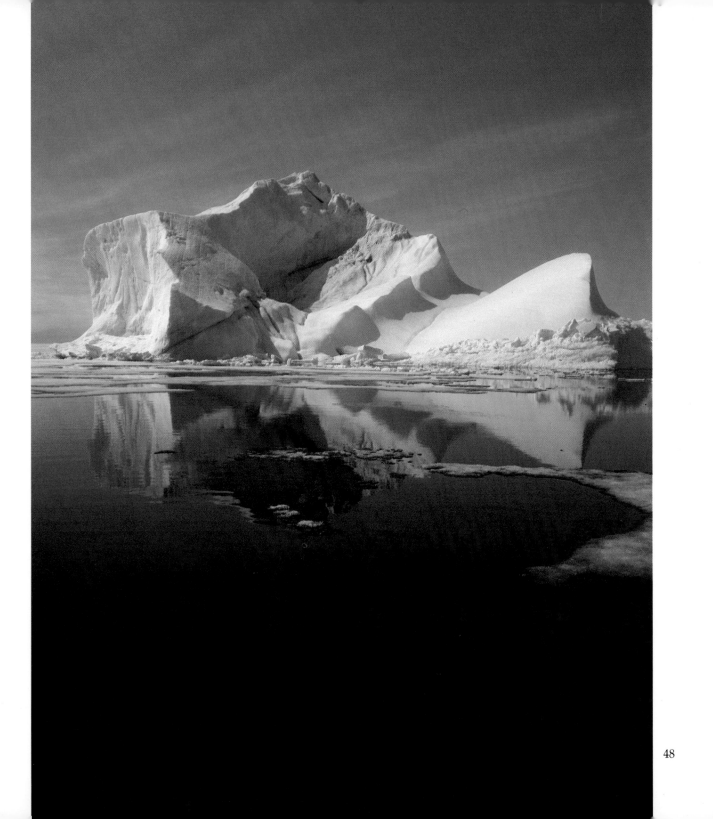

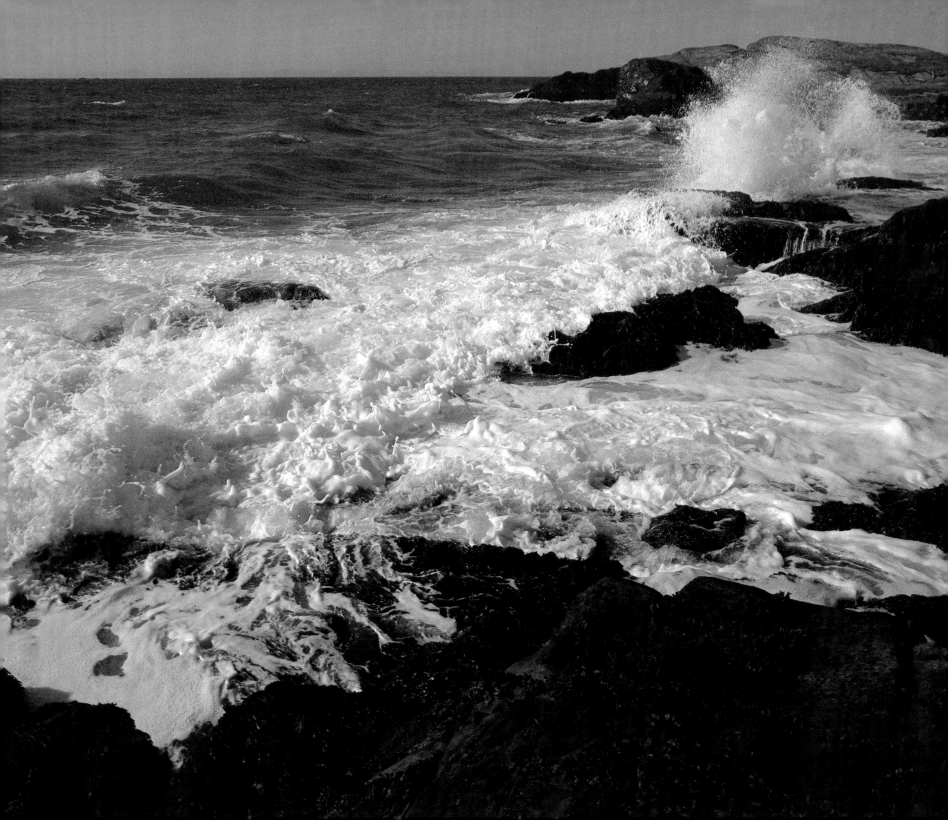

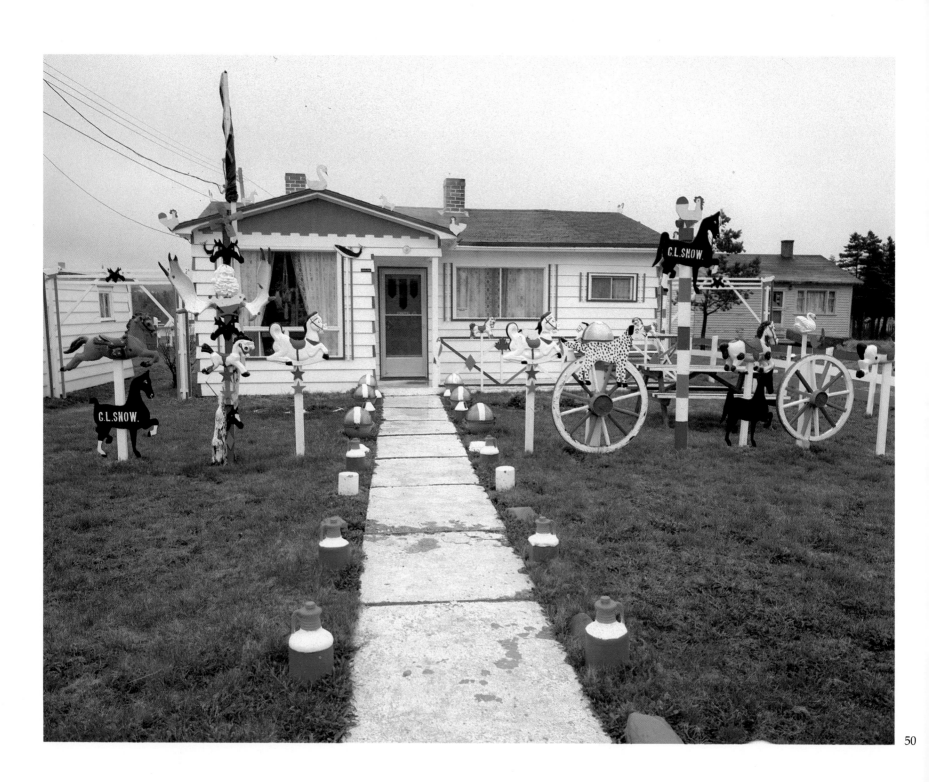

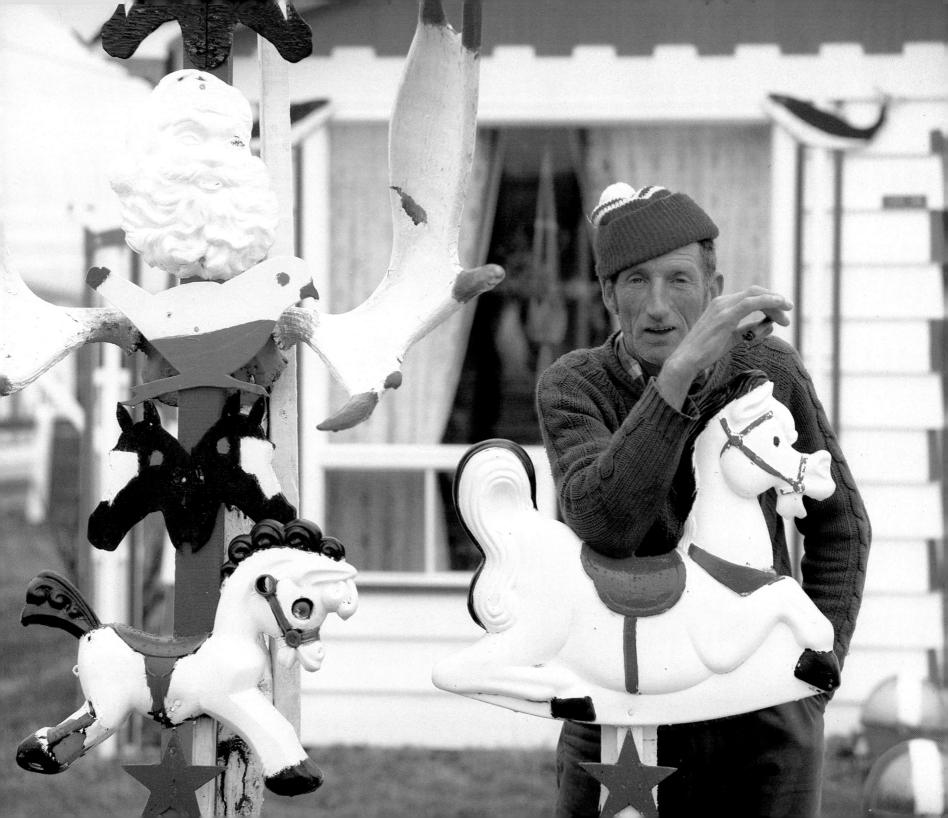

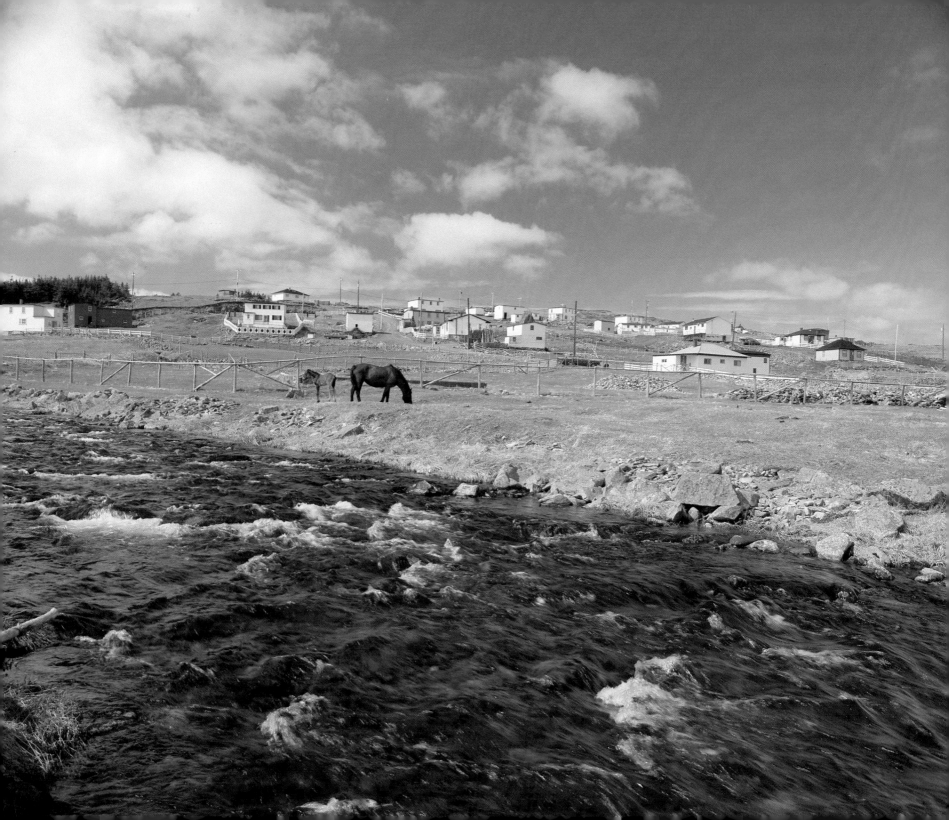

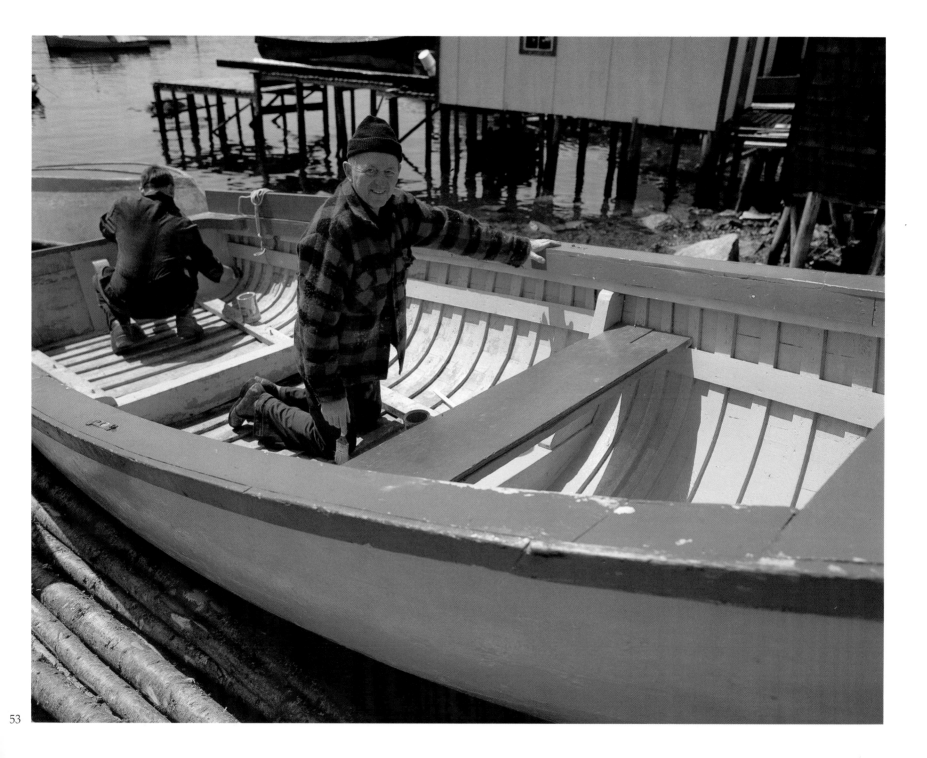

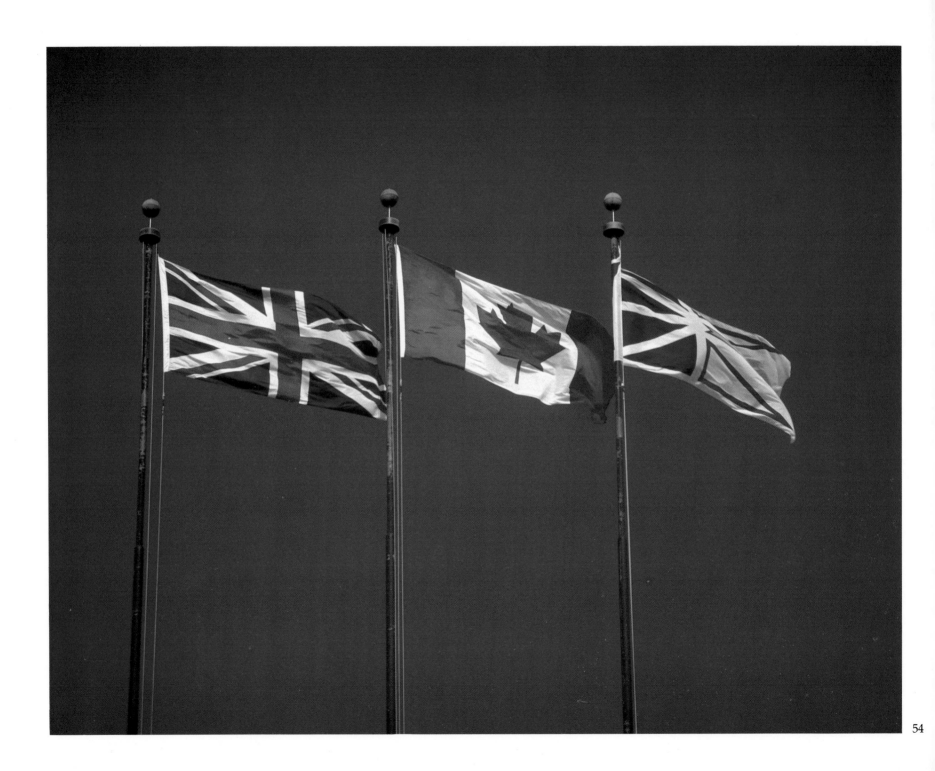

54

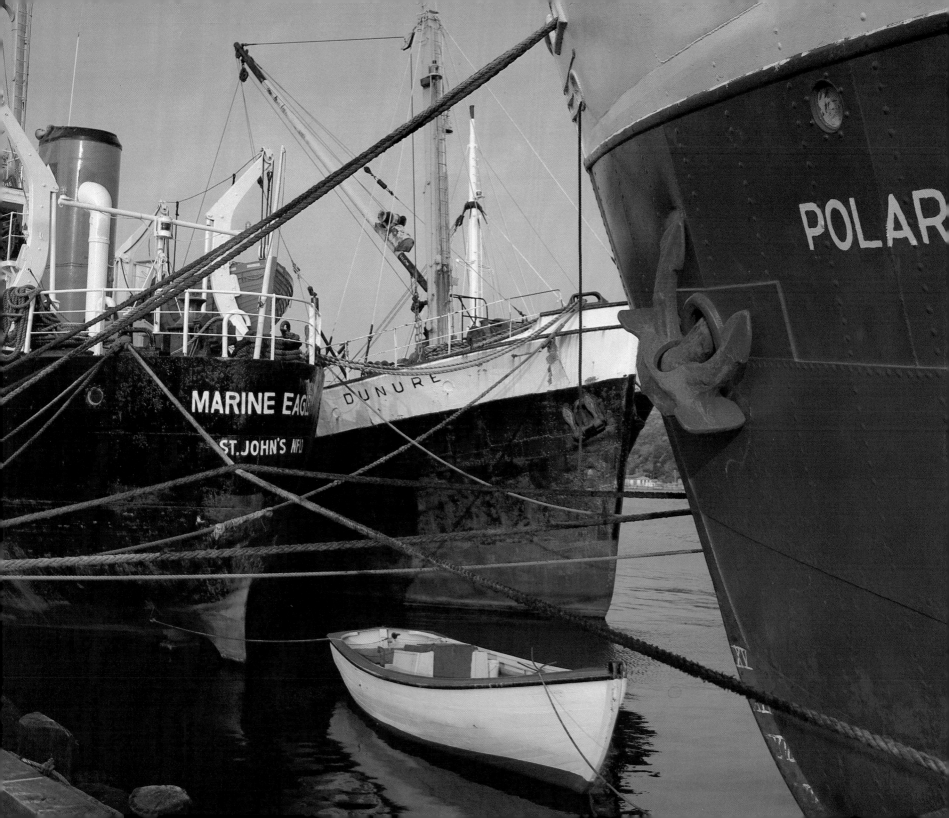

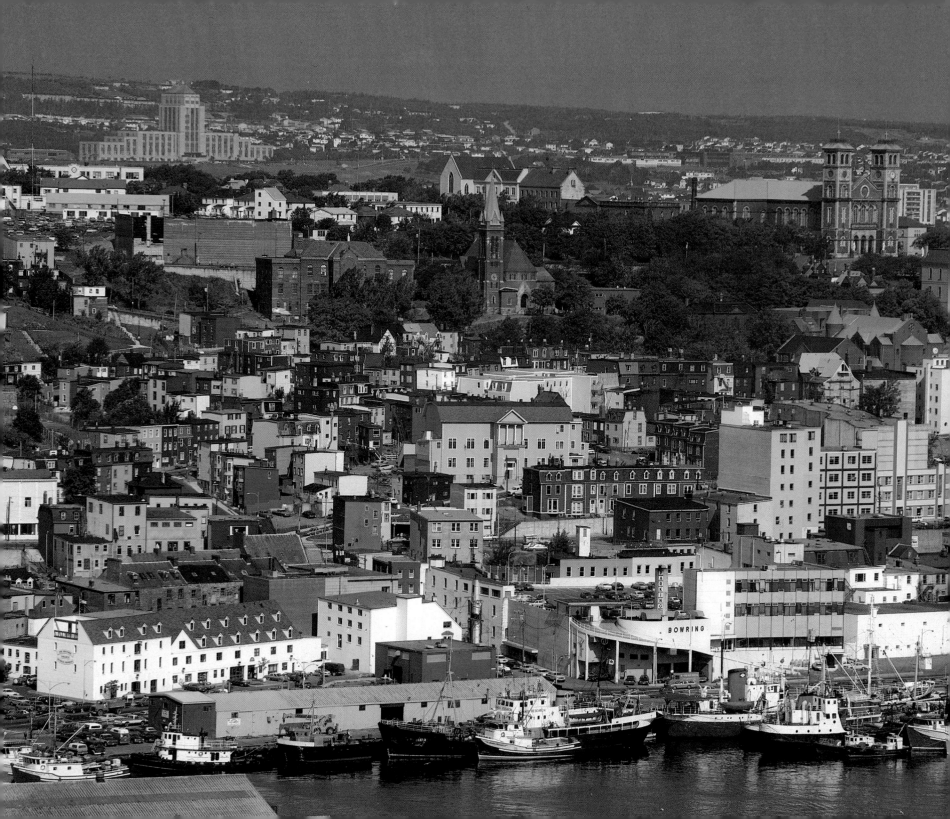

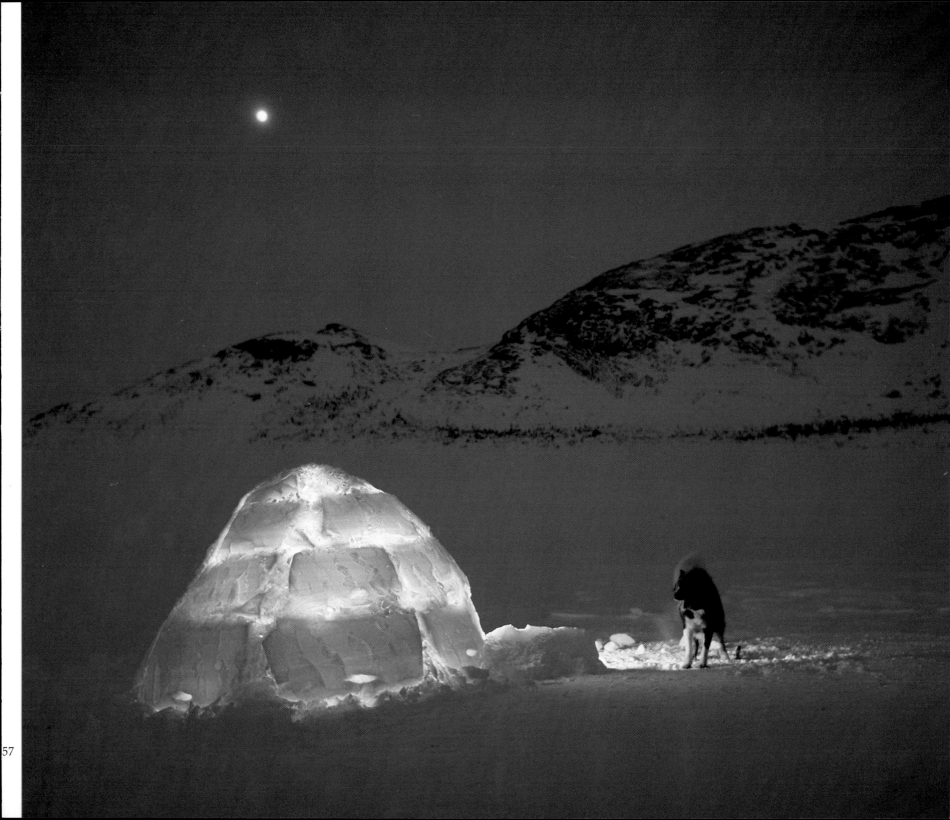

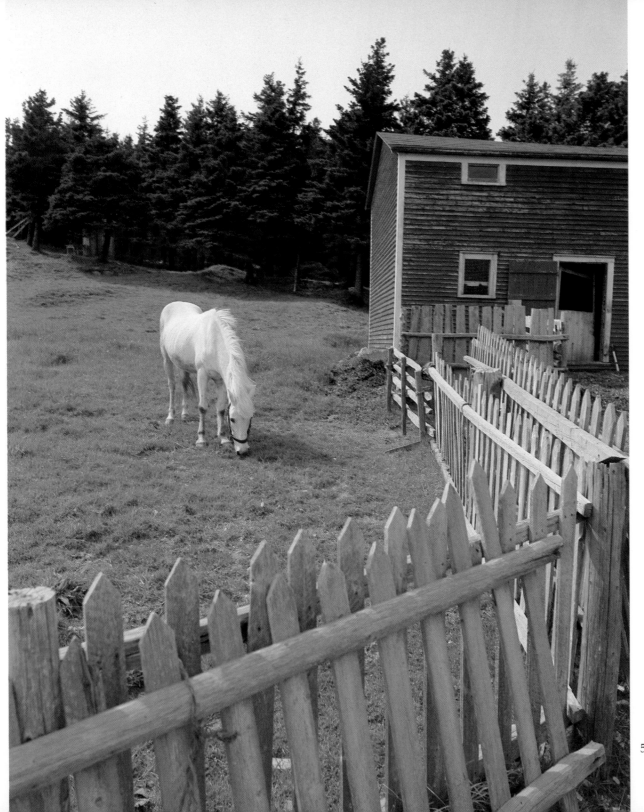

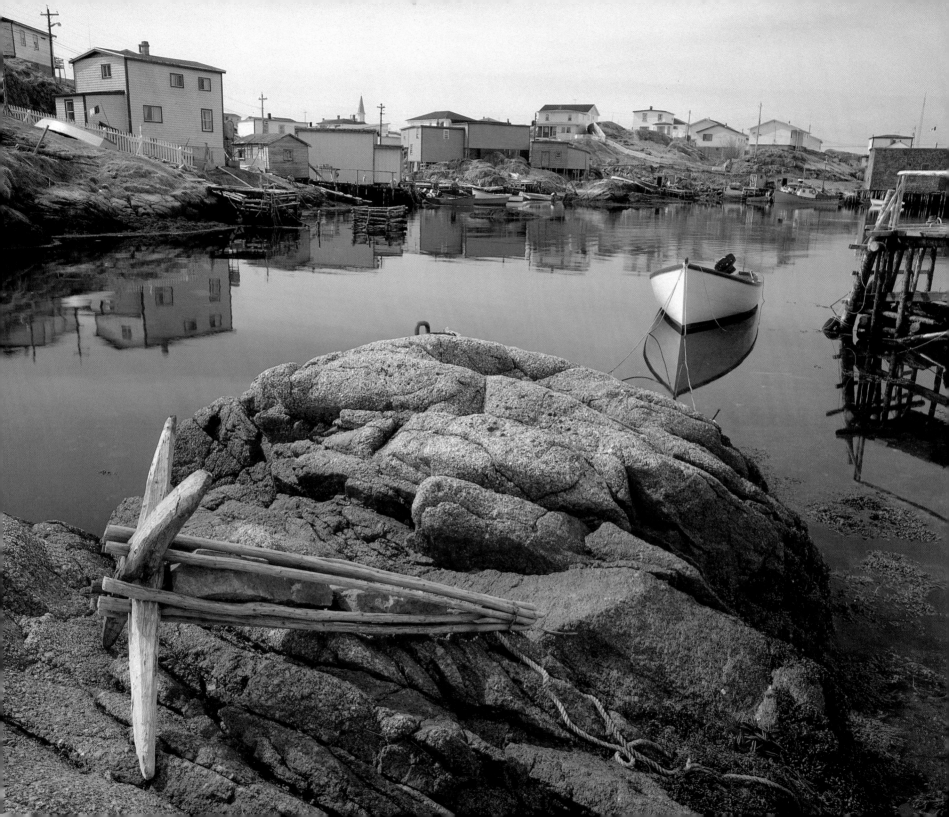

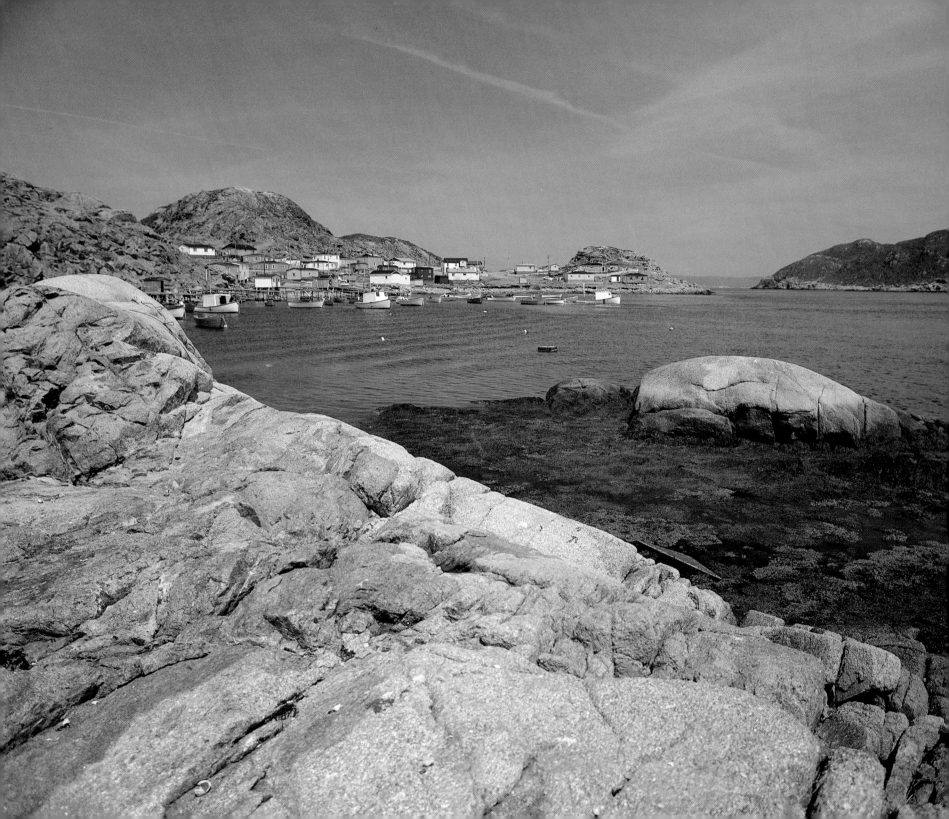

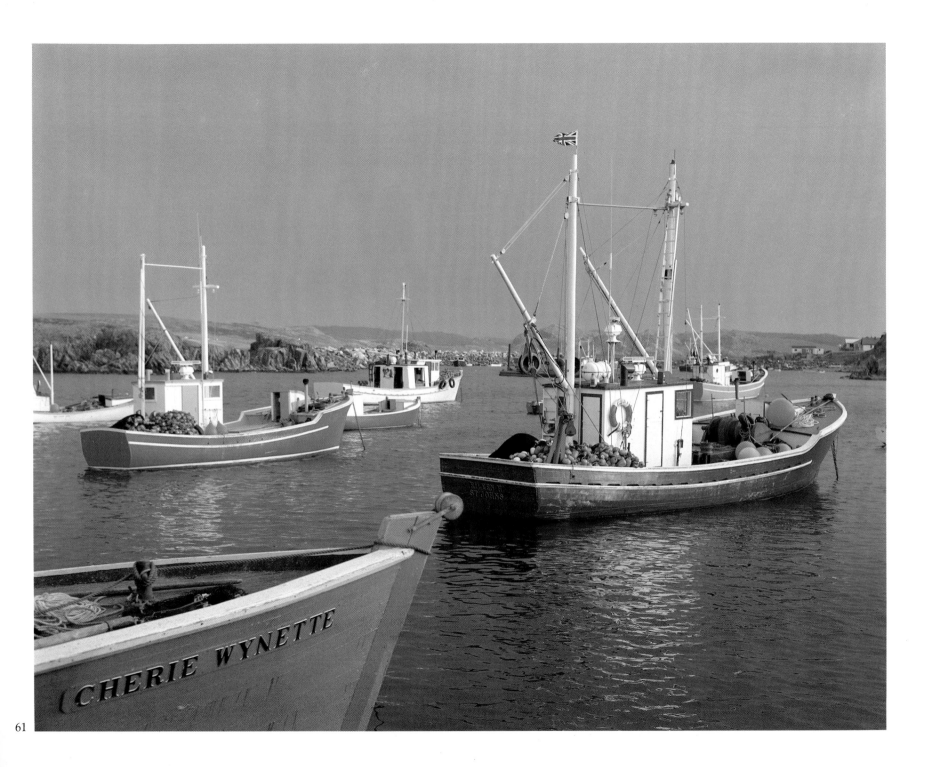

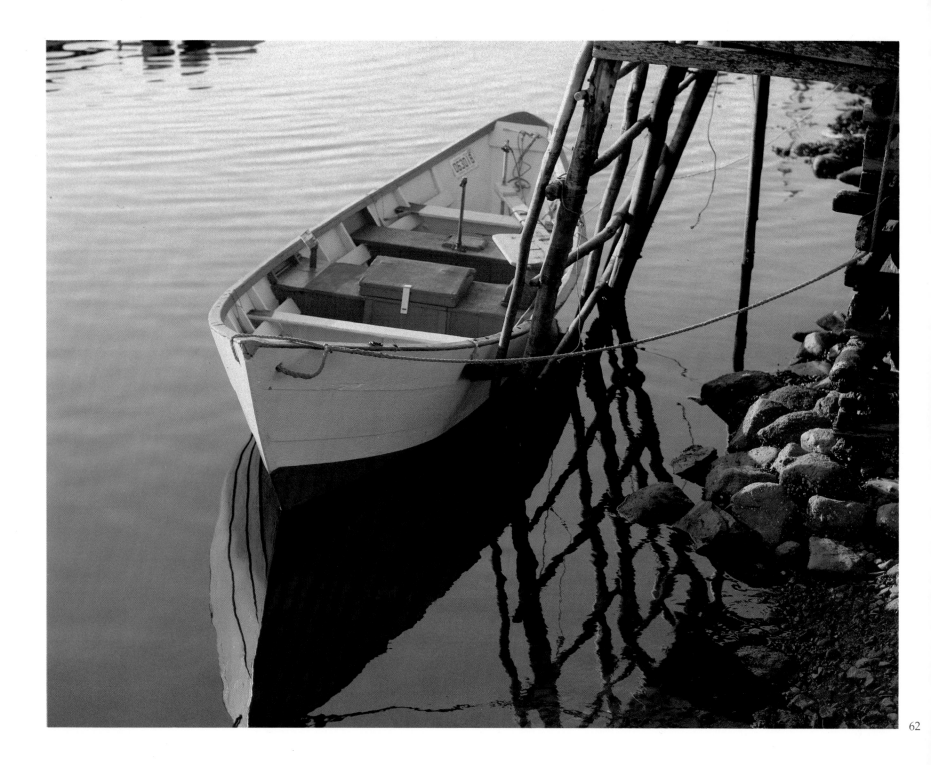

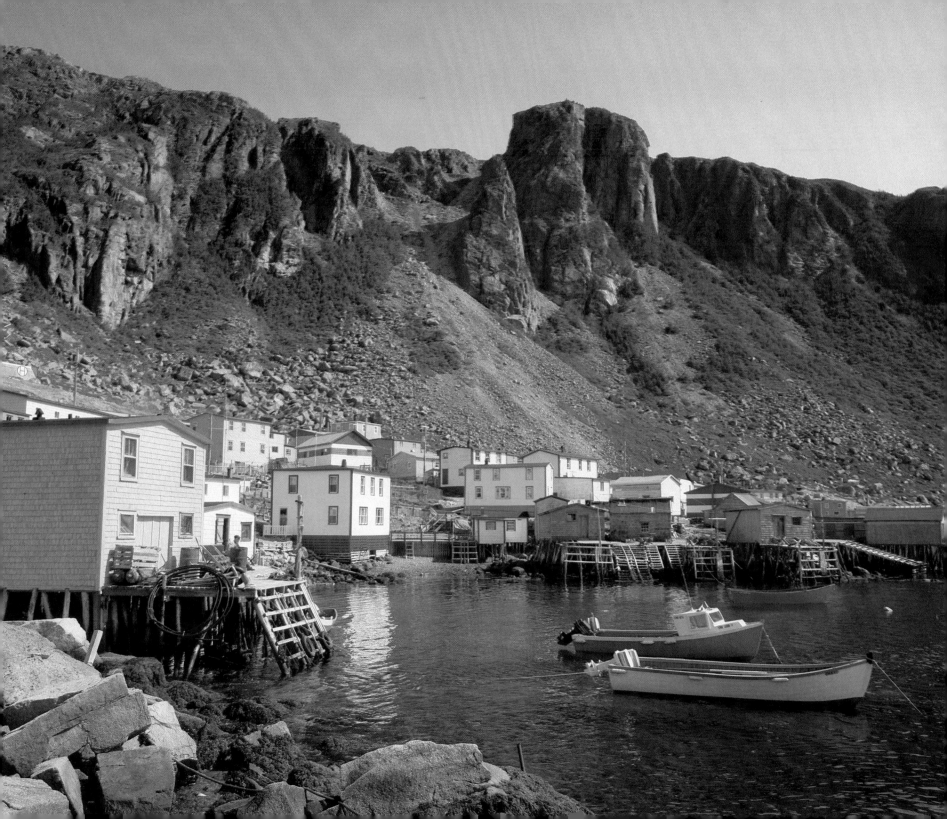

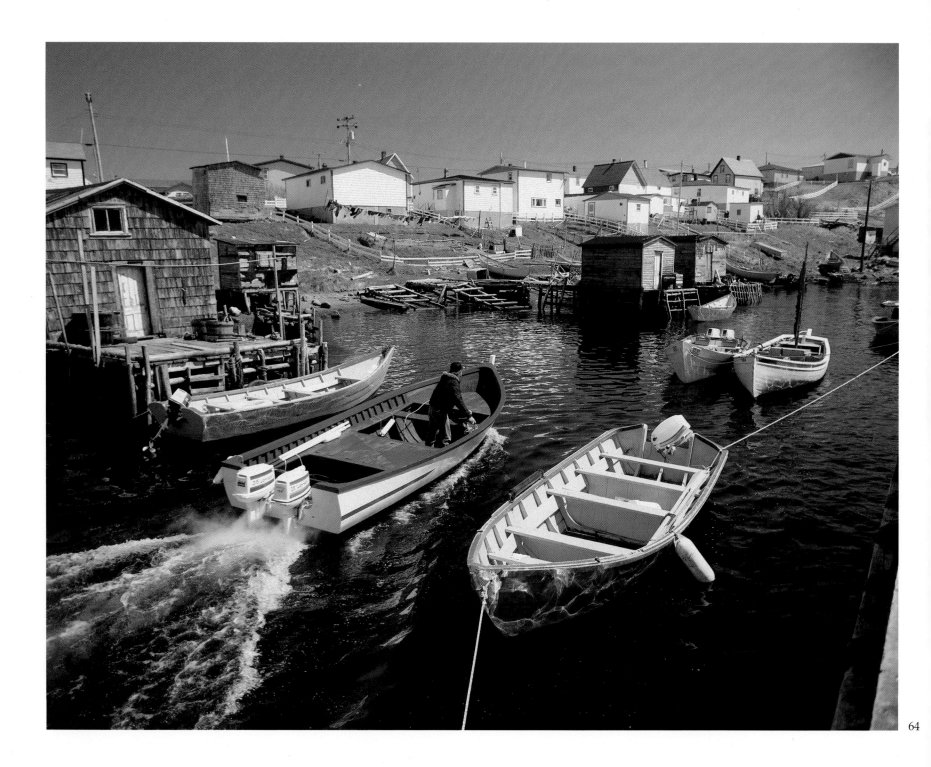

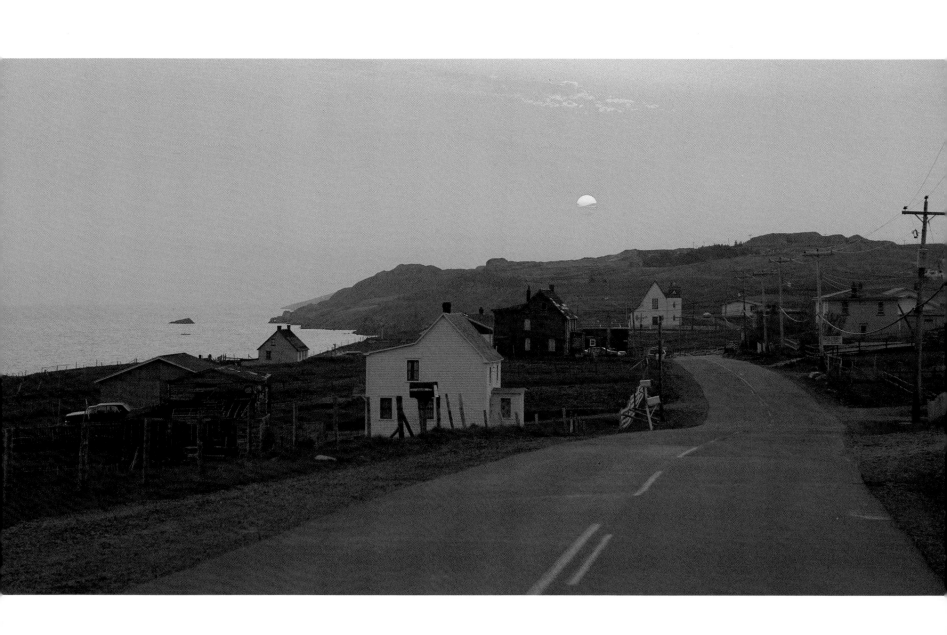

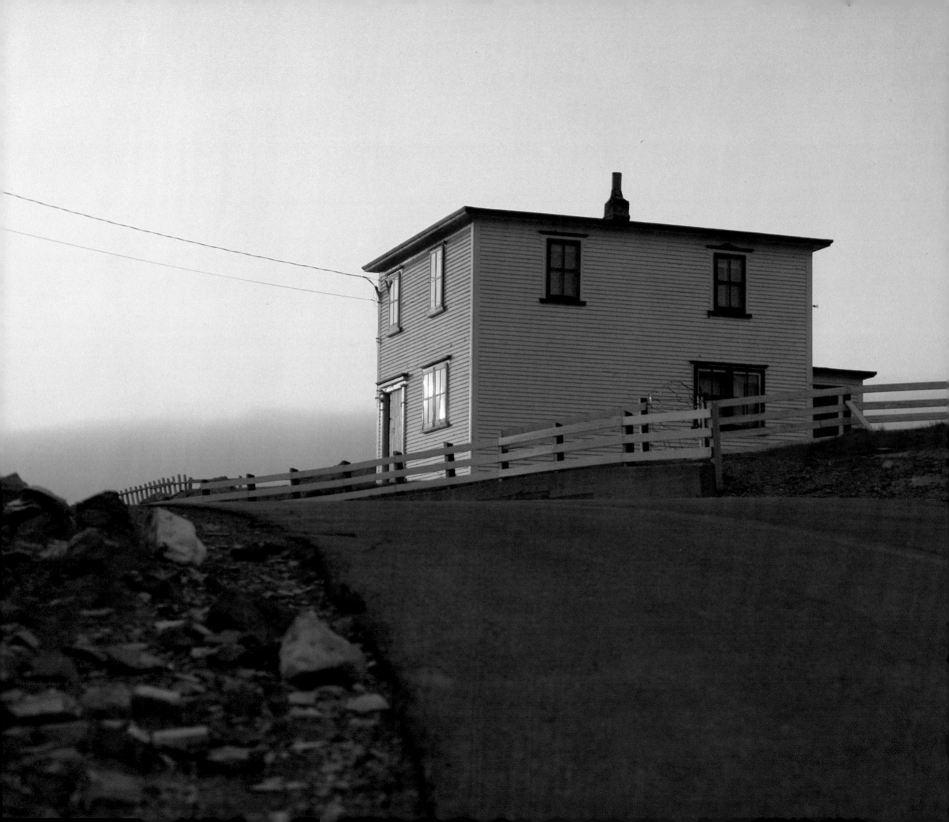

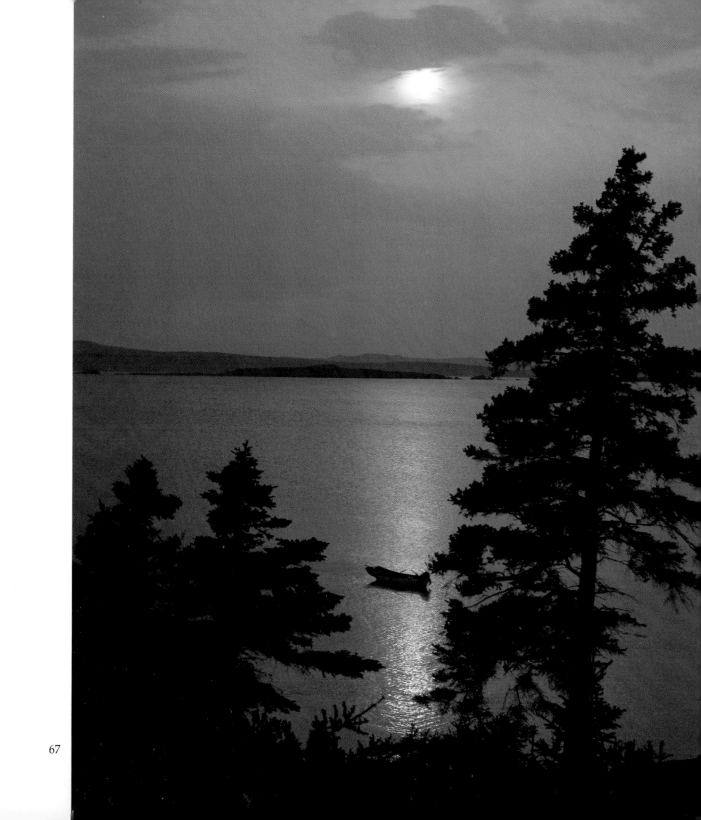

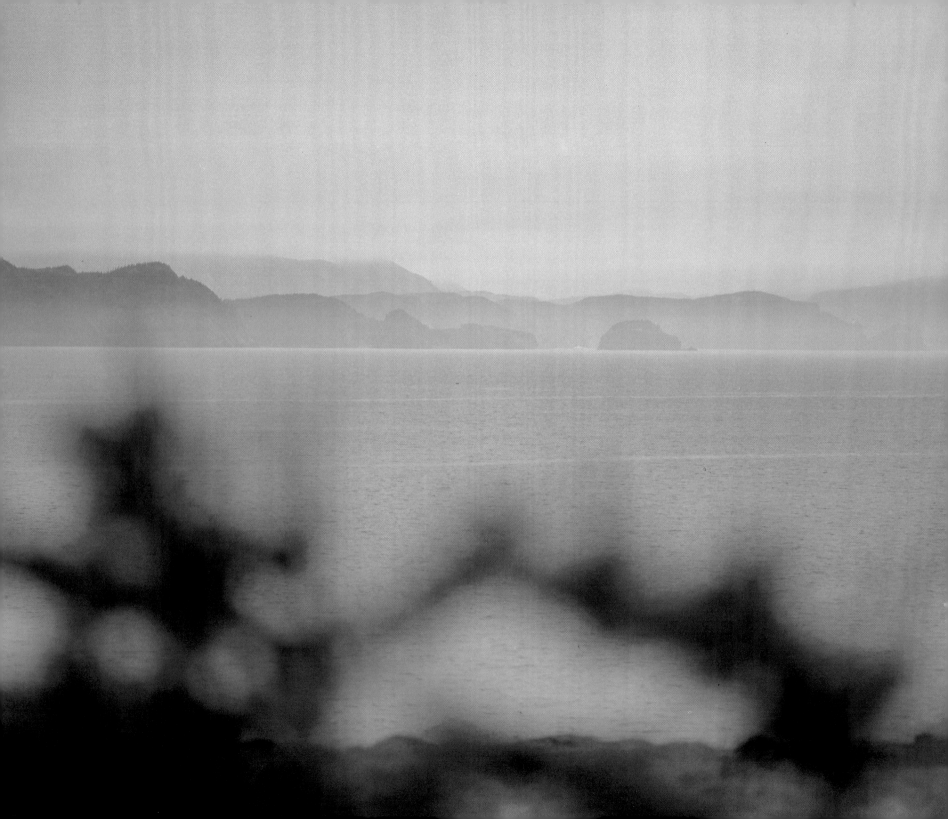